WELWYN & WELWYN GARDEN CITY

THROUGH TIME

Tony Rook

AMBERLEY PUBLISHING

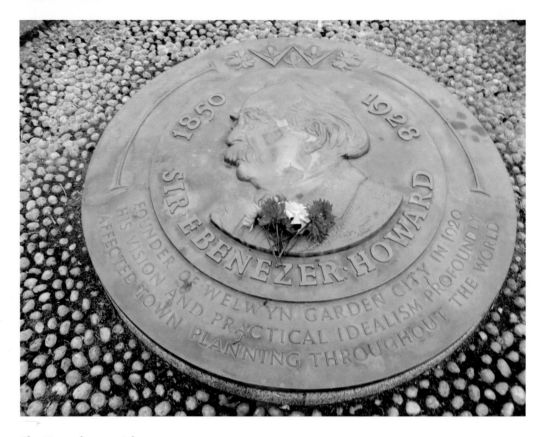

The Howard memorial.

First published 2013

Amberley Publishing
The Hill, Stroud, Gloucestershire, GL5 4EP
www.amberley-books.com

Copyright © Tony Rook, 2013

The right of Tony Rook to be identified as the
Author of this work has been asserted in accordance with
the Copyrights, Designs and Patents Act 1988.

ISBN 978 1 4456 2084 8 (print)
ISBN 978 1 4456 2095 4 (ebook)

British Library Cataloguing in Publication Data.
A catalogue record for this book is available from the
British Library.

Typesetting by Amberley Publishing.
Printed in Great Britain.

Introduction

Welwyn is an ancient settlement on the River Mimram in the middle of Hertfordshire. Rich burials uncovered during the excavation when the Hertford (Station) Road was diverted in 1906 (*p. 90*) show that it was important in the Pre-Roman (Belgic) Iron Age. On the west side of the river, a Roman town grew on the main Roman road from St Albans to Colchester, and two Roman villas have been found nearby. We can judge the size of the Roman settlement from the cemetery at The Grange, which contained several thousand burials. In the Dark Ages, there was a *monasterium* at Welwyn, and in the seventeenth century the town became a thriving coaching town on the Great North Road. By the beginning of the twentieth century, Welwyn was the administrative and commercial centre for the whole of mid-Hertfordshire, with a Rural District Council, GPO, Police Station, numerous factories and shops, a gasworks and a main line railway station. It had at least fifteen public houses!

The land around the town of Welwyn was largely agricultural when, in 1919/20, Ebenezer Howard and his supporters bought nearly a thousand acres of it, which was mostly in the Rural District of Welwyn. Here, the developers began to build a new town called 'Welwyn Garden City'. Although it was entirely separate from Welwyn, its inhabitants soon omitted the 'Garden City' and today many reference works persist in this error.

In 1946, Parliament made Welwyn Garden City one of the 'New Towns' intended to take overspill population from London. These were developed not by private companies but by government appointed quangos called Development Corporations. At last the town became connected to the outside world by proper roads, and the virtual monopoly over trade and industry held by the Garden City Company was broken. The mobility made possible by the universal ownership of motor cars meant that Garden City shops flourished at

the expense of those of the real Welwyn, which became referred to as 'Old Welwyn' by outsiders and 'the Village' by its inhabitants.

When it came to selecting suitable old and new pictures, I found that because Welwyn Garden City is less than 100 years old, little has changed in the residential areas – except the trees have grown! Radical alterations have occurred in the industrial area but cannot be covered by before and after pictures. For example, the largest industrial complexes, such as ICI, Murphy Radio and Dawneys left not a wrack behind (*p. 39*).

Acknowledgements

I have made use of the wealth of old pictures in public and private collections, including my own. Several copies of the same picture are often found in all of them and it would be difficult, if not impossible, to discover their origins. Their quality might not be brilliant, either because of the original photography or because of poor copying, but their historic value outweighs this. I am particularly grateful to the Local Studies Libraries of Hertfordshire County Council at Welwyn Garden City, the Museum Service of Welwyn Hatfield Borough Council, and Paul Jiggens. I intend to give to them, on disc, the collection of more than 250 pictures I have made while producing this book. I shall be glad to hear from and to compensate anyone whose copyright I have unknowingly infringed.

Dennis Lewis and Andrew Carnegie helped with the captions, but I am quite capable of making my own errors! I thank Nick Tracken and Jon Wimhurst for helping me to get to the right places. Nick helped me find the right viewpoints.

Workmen's Huts

In order to house their labour force, the Garden City Company erected army surplus huts in the woods north of Hunter's Lane (now Bridge Road), approximately on the site of the modern Campus West.

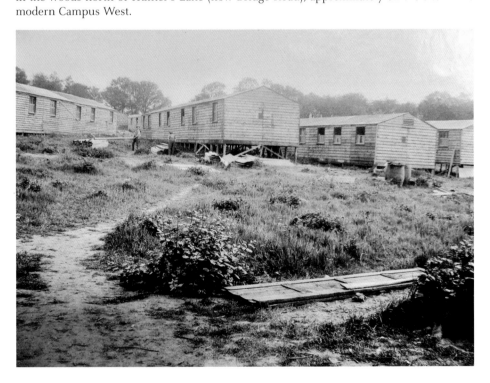

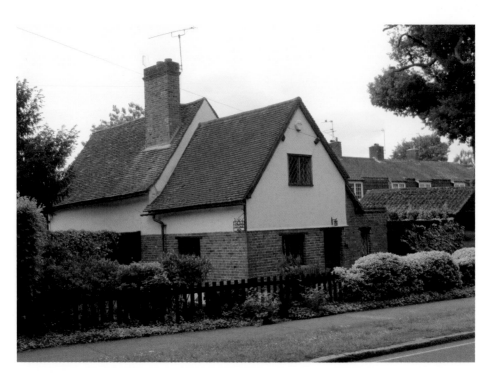

The Old Cottage

One of the few ancient buildings left in the Garden City, the brick-built 'Old Cottage', No. 39 Bridge Road, has a date of 1604 attached to it, but there does not seem to be any justification for this. Its history and the reasons for its survival seem to be mysteries. The original road past it, Hunters' Lane, can be seen opposite it as a sunken way with surviving hedges.

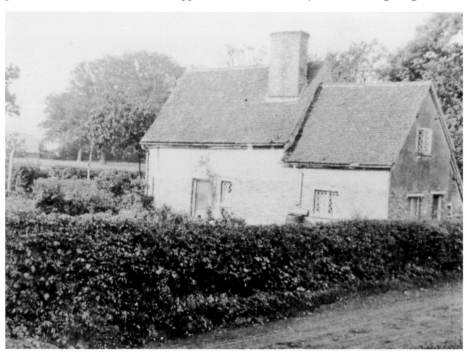

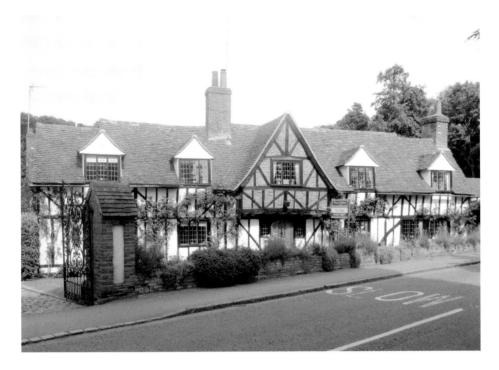

Cottages at Digswell Water

An astonishing central gable was added to this simple row of cottages when they were made into one house. More recently a huge extension has been added, and the house is now named Mimram House, recently advertised as 'a stunning Grade II listed house dating from the 16th century' with an asking price of £2.1 million.

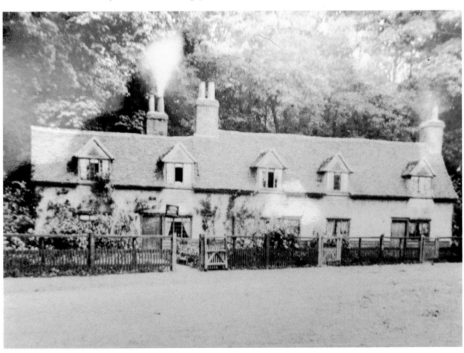

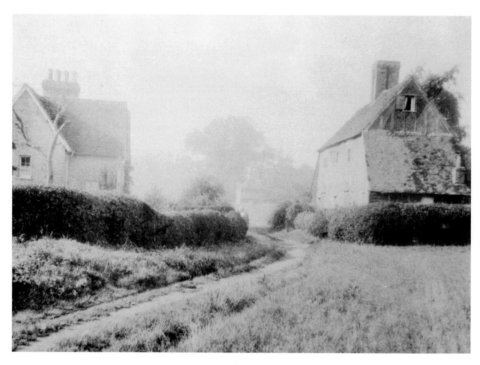

Black Fan

Probably originally 'Black Fen', this settlement appears on a map dated 1599. It was in the valley that is now beside 'Waterside', which leads into Welwyn Garden City from the Hertford Road. The site of the cottages is now a somewhat polluted 'lagoon' that intercepts the runoff from surrounding roads.

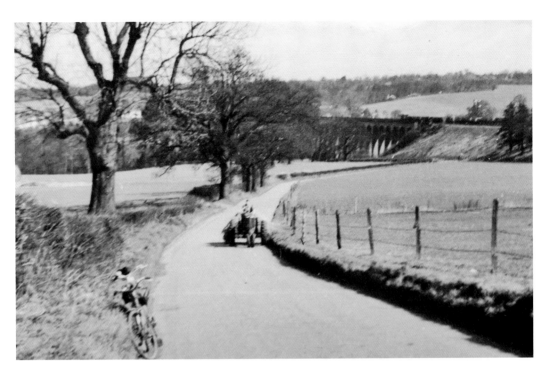

Harwood Hill

This was originally Digswell Lane, which went down through the fields beside the railway, under the viaduct and past Digswell Mill to the Hertford Road. It became a residential cul-de-sac when Digswell Hill and Bessemer Road were constructed.

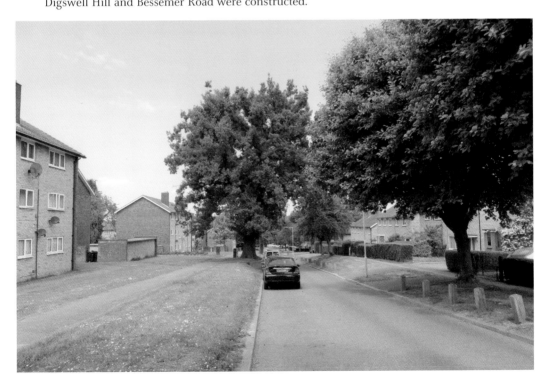

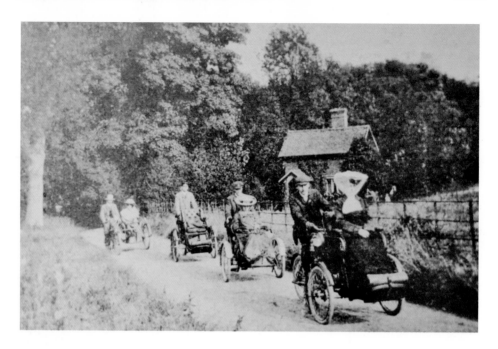

Digswell Park Road

The land around Digswell House was enclosed to make a park, probably in the thirteenth century, and the village was moved to Digswell Water. The public road then had to go around its edges, and its route can be followed from under the viaduct as far as Monks Walk School. A drive led from it to Digswell House, with a lodge house at the gate. Bessemer Road cut off the lodge (and Digswell Lake). The picture below from a motoring magazine at the beginning of the twentieth century is captioned 'Approaching Digswell on the Great North Road'. They are approaching the Great North Road from Digswell.

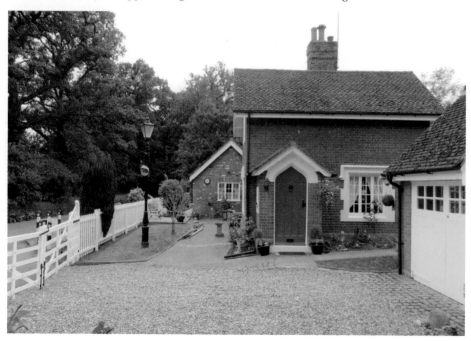

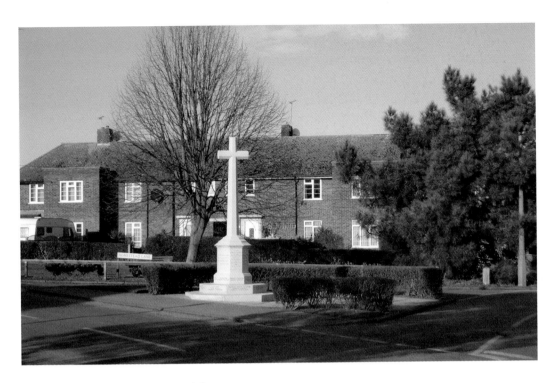

Hatfield Hyde War Memorial

The war memorial at the junction of Hollybush Lane and Homestead Lane lists the names of twenty-two men from Hatfield Hyde and Mill Green who died in the First World War. Hatfield Hyde was a hamlet, which has been swallowed up by the expansion of Welwyn Garden City.

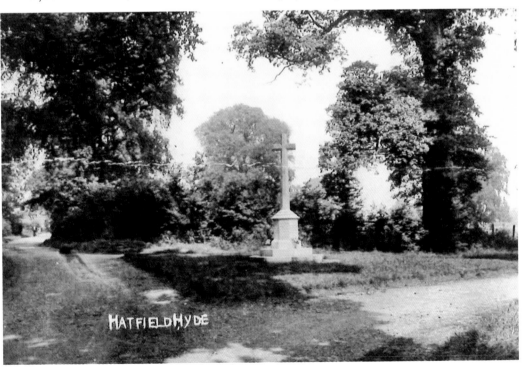

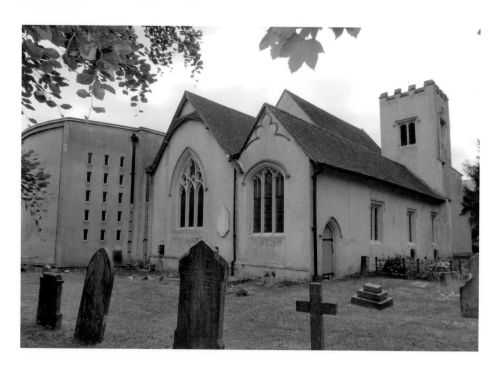

Digswell Church

St John's parish church, Digswell, is supposed to have been built by Geoffrey De Montfort. During recent stripping of plaster in the interior, I found evidence that suggests an earlier date. In the early 1960s, a huge barn-like extension was added. Its situation beside the original manor house is evidence that the original village was moved when the area was imparked (*see pp. 10, 92*).

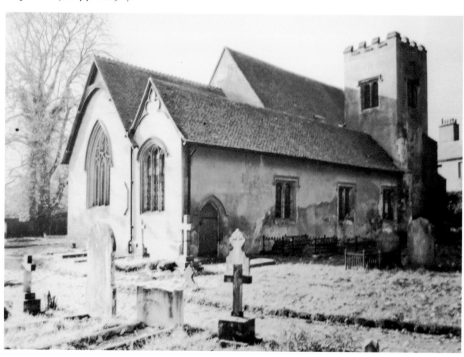

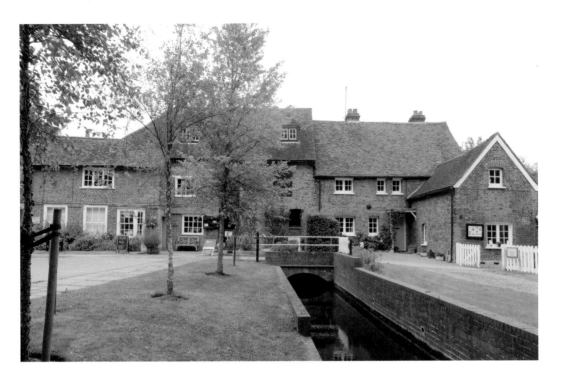

Mill Green Mill

Most of the mills in the area have ceased work, and have either been demolished (if they were clapboard buildings) or converted into dwellings (if of brick). Mill Green mill is unusual. Restored by the Mill Green Restoration Trust in 1986, it is now working as part of Welwyn Hatfield Museum.

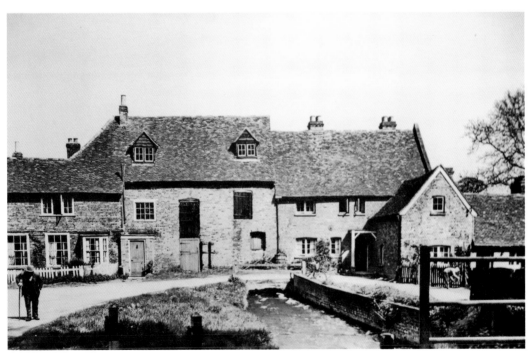

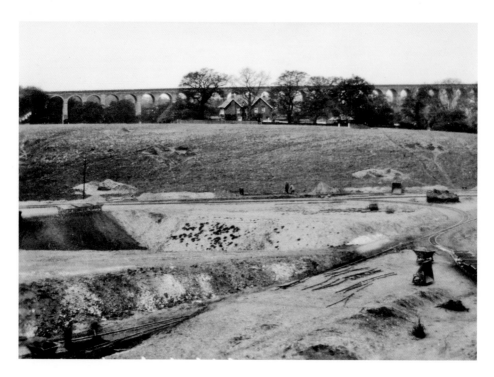

The Viaduct from Digswell Water Gravel Pit

The viaduct is a notable example of industrial archaeology. Designed by Cubitt and constructed by Brassey, it was completed in 1850. In the 1920s, the light railway used in the construction of the Garden City extended to this gravel pit. Old inhabitants tell of the exciting ride they took all the way down the steep slope from the campus – if they weren't caught!

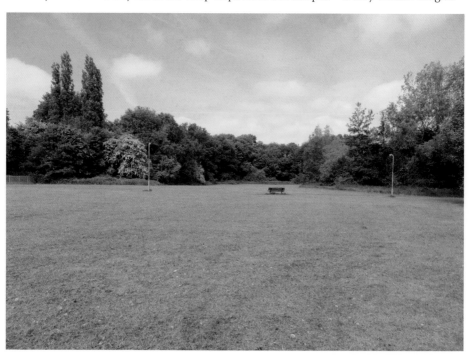

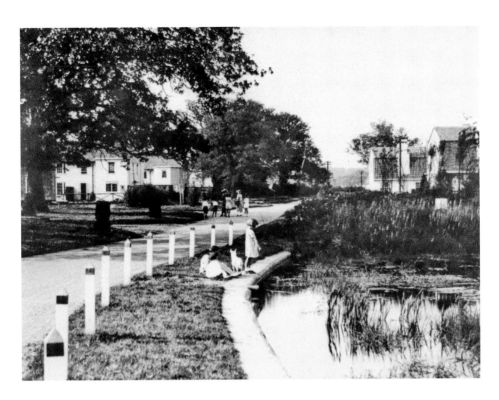

Handside Pond

The pond opposite Meadow Green belonging to Lower Handside Farm was featured, with the children playing beside it, on a poster derived from this photograph advertising the Garden City. It was soon filled in, presumably as a health hazard!

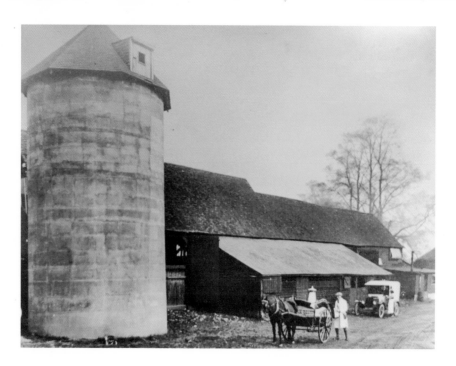

The Barn Theatre

Lower Handside Farm was converted into a model dairy around 1920, and sixty longhorn cattle were housed in a barn that had been moved there from Handside Village a century earlier, and had been used for public meetings. In 1931, the barn was converted into a theatre, owned and run by amateurs. The tall, white tower is a silo.

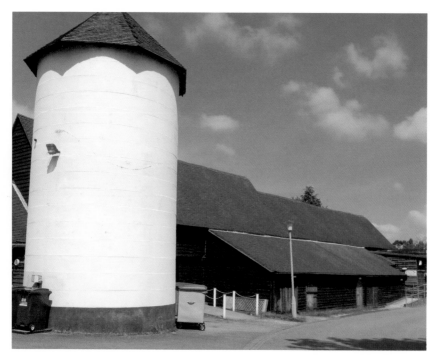

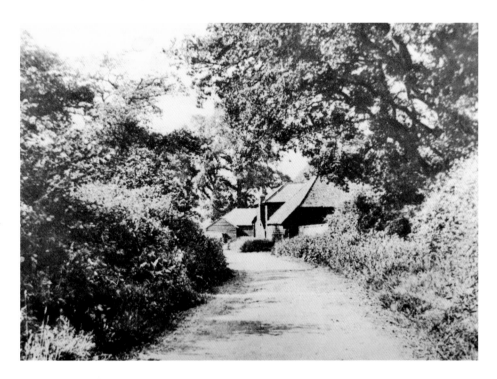

Upper Handside Farm

Although it has been slightly improved by highway engineers, Handside Lane still preserves some vestiges of its origin, such as lengths of old hedgerow. Upper Handside Farm, seen in the old picture, was demolished. Its seventeenth-century timber-framed cart house is now a meeting room and a memorial to the climber Edward Backhouse.

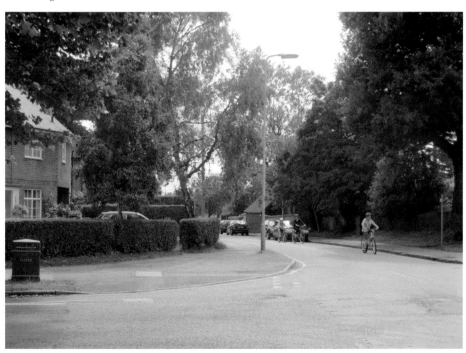

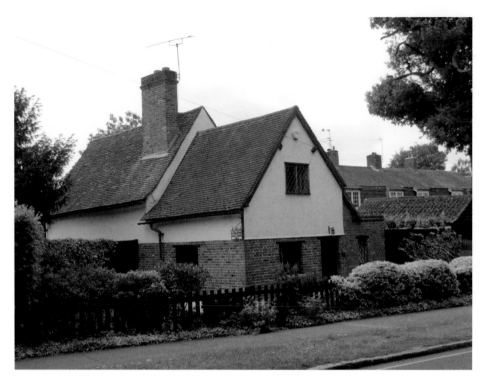

The Old Drive
The Old Drive, photographed here in 1929, was originally the tree-lined road to Upper Handside Farm.

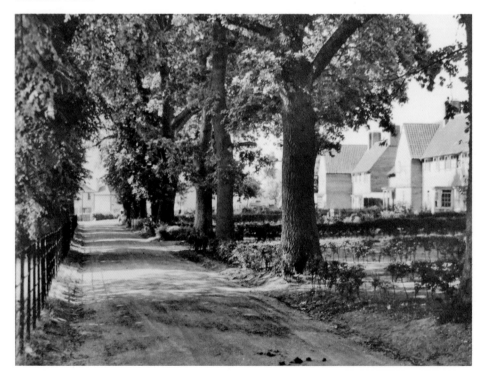

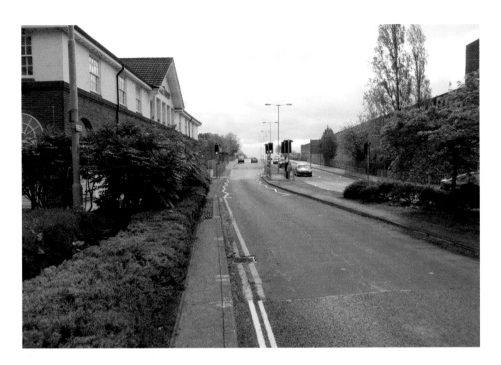

Hunters Bridge

A bridge was provided by the Great Northern Railway when the railway was constructed in the mid-nineteenth century to continue a right of way of an unmetalled track used mainly for farming. To give height over the tracks, it was approached on both sides by steeply inclined embankments. The gradients have been reduced, and it has been progressively widened and now carries a dual carriageway.

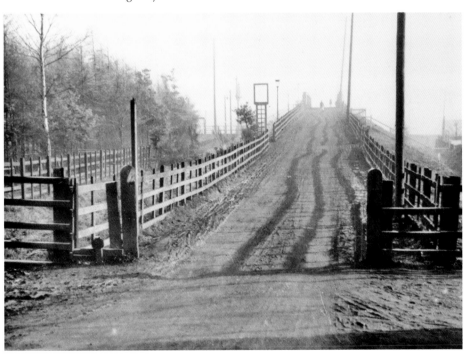

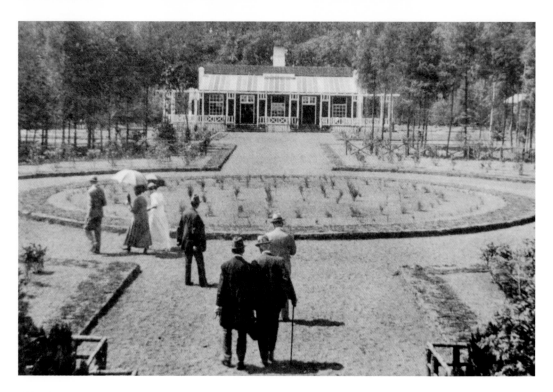

The Cherry Tree Restaurant

The Garden City Company realised that they needed a pub for the workers, with a licensed restaurant for the salaried class. The building, The Cherry Tree, was of timber. A brick-built public house replaced it in 1932, and the formal gardens became a bowling green. They are now the two-storey car park for Waitrose, which occupies the extended building of the old Cherry Tree. The early photograph was taken from the railway station (*p. 31*).

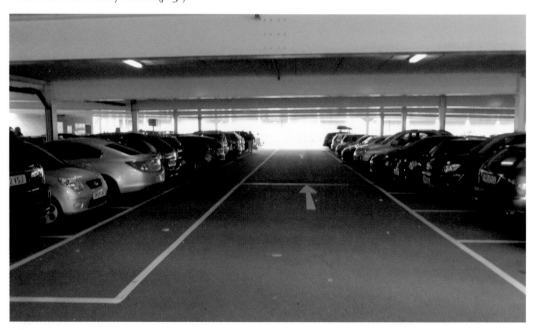

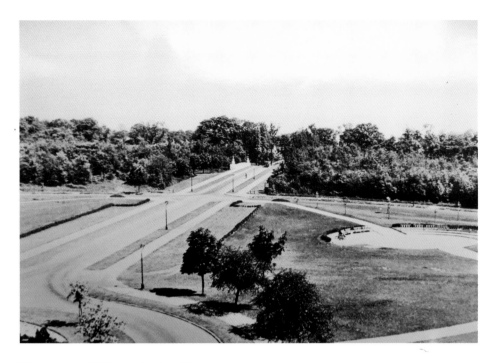

The Campus, Welwyn Garden City

A D-shaped area of grass was the focus of the formal layout of the city. It originally consisted of two concentric semicircular roads. It was therefore two half roundabouts in which traffic priorities were uncertain. Eventually the inner one and its feeder from the north were closed. Campus West, the Library of de Havilland College (now Oaklands College) and the 'new' Police Station (now demolished) were built in the woodland.

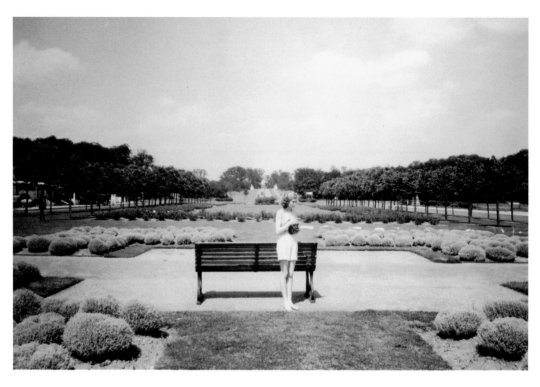

Parkway

This dual carriageway avenue running north–south is the formal centerpiece of the Garden City. The view is looking north towards the White Bridge, which can be seen in the 1950s photograph.

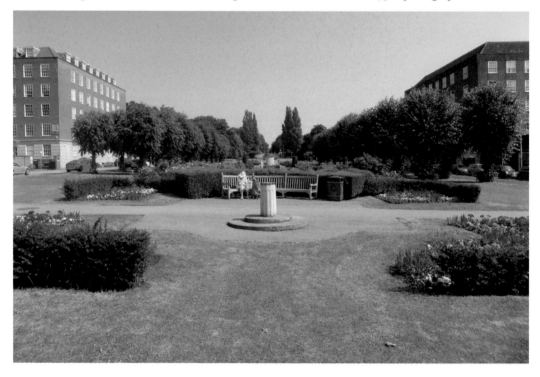

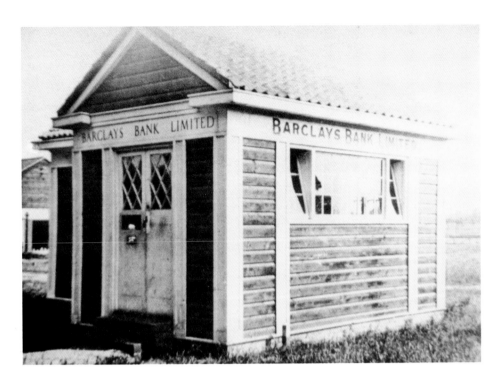

The First Banks

To anyone of the Old School who expected banks to be solid and impressive structures, the first ones in the Garden City must have been a bit of a joke. Before the formal layout of the city centre had begun, two diminutive banks are shown by the Ordnance Survey on Bridge Road. Barclays was probably the one where Parkway was created.

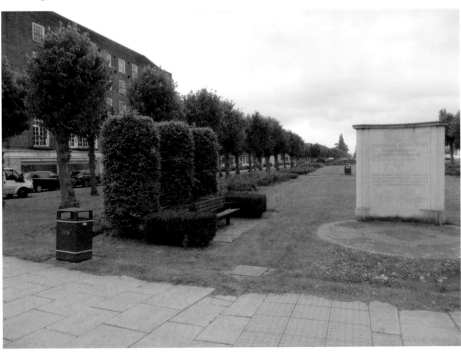

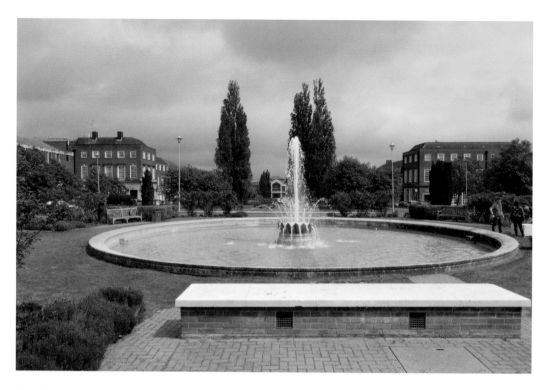

The Coronation Fountain

The fountain was constructed at the junction of Howardsgate and Parkway to mark the coronation of Queen Elizabeth II in 1952. The Shredded Wheat factory is in the background of the old picture – the Howard Centre of the modern one.

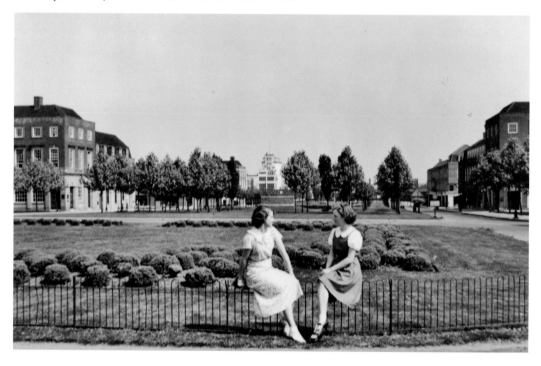

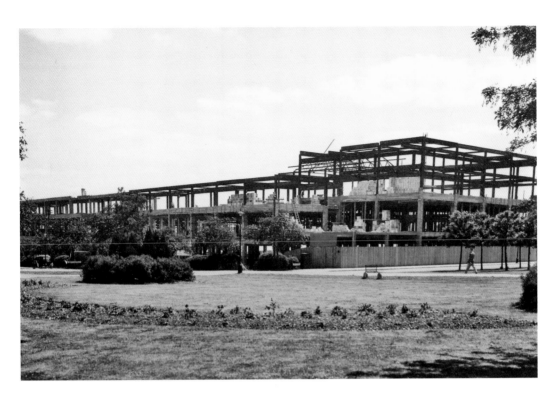

Welwyn Department Stores
The construction of a new department store by the Garden City Company was completed just before the outbreak of war in 1939. After the Welwyn Garden City Company was liquidated, the stores were owned by Fine Fare. They are now owned by the John Lewis Partnership.

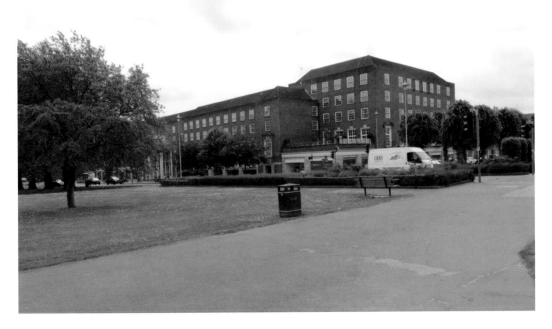

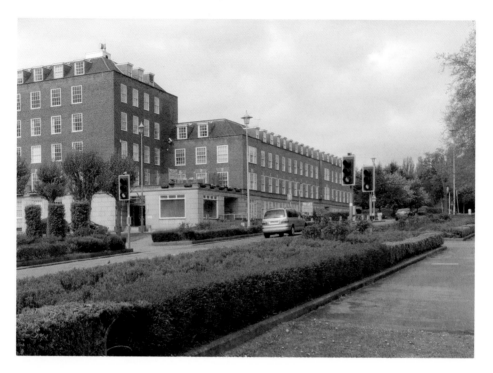

Rosanne House

The first Welwyn Stores was on the north-west corner of Parkway and Bridge Road. It was a low, hangar-like building with a single-storey café and a cinema attached. It closed when the present stores (now John Lewis) opened on the other side of Parkway in 1939. The old building was used by the municipal dustcarts until Rosanne House was built in the 1960s.

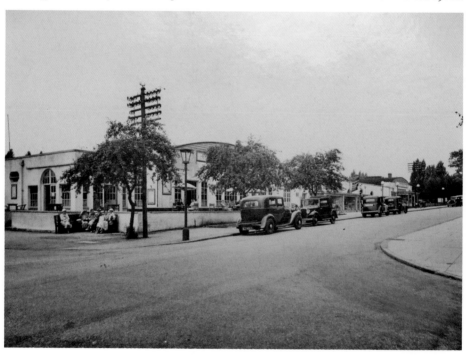

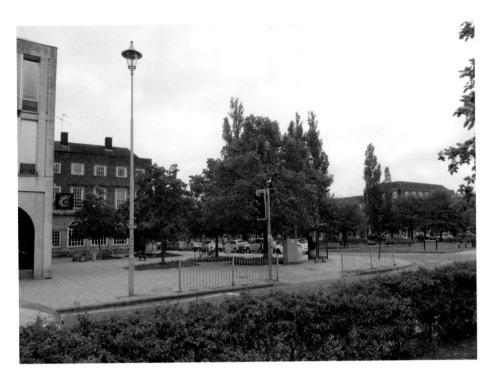

Howardsgate Banks

To emphasise the importance of banks, they had the earliest and most imposing buildings at the west end of Howardsgate, at its junction with Parkway. The Welwyn Theatre and Barclays Bank are on the left of the old picture, with Midland bank on the right.

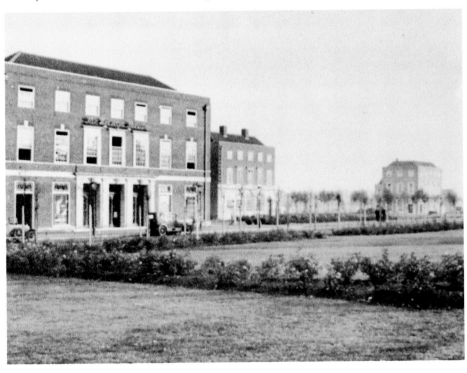

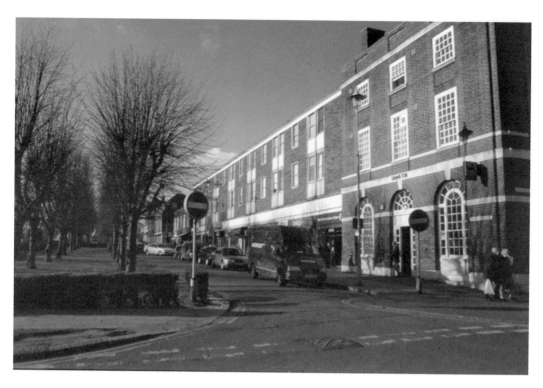

Howardsgate Shops

The original single-storey shops at the east end of Howardsgate were constructed in the 1930s. A second storey was added in the 1950s. This is now built of brick, steel-framed and clad in 'mathematical tiles'.

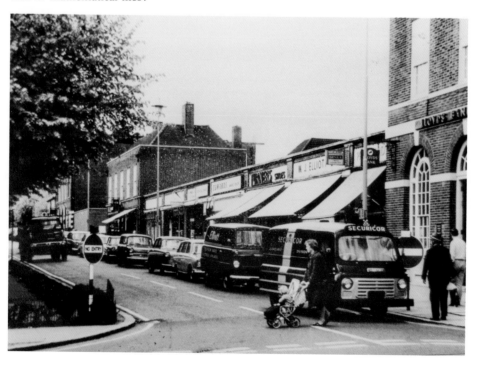

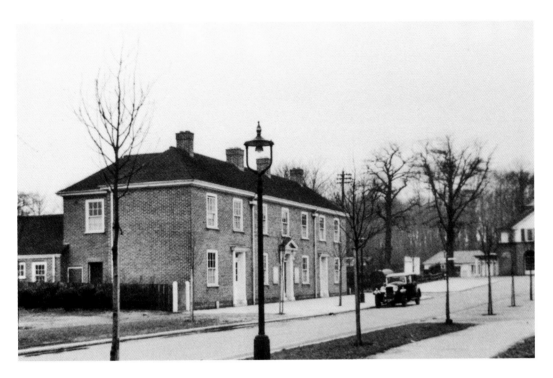

Welwyn Garden City Police Station

The mid-Herts Police Station moved from Church House, Welwyn, to old Vine Farm, No. 31 Church Street (now the veterinary surgery) at the beginning of the twentieth century, and to a purpose-built building in Stonehills, Welwyn Garden City, in 1933. This was demolished in 1962 and a new station was opened on the east side of the campus. This has been replaced by flats, and a small office opened in Rosanne House, Bridge Road.

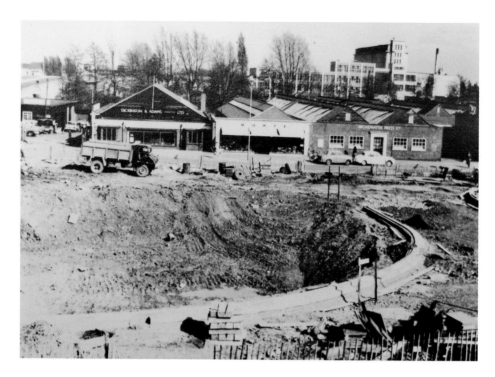

John Lewis Roundabout

This curious sunken feature was constructed in the early 1960s on what was previously intended to be a prime commercial site. The hole in the middle allows adventurous pedestrians to find their way through, but wheelchair users and pram-pushers cannot escape at the east side! It contains public lavatories, which are never open.

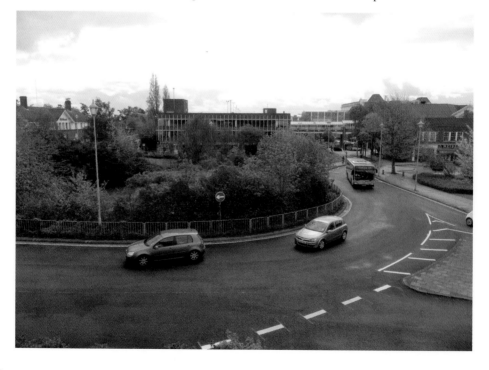

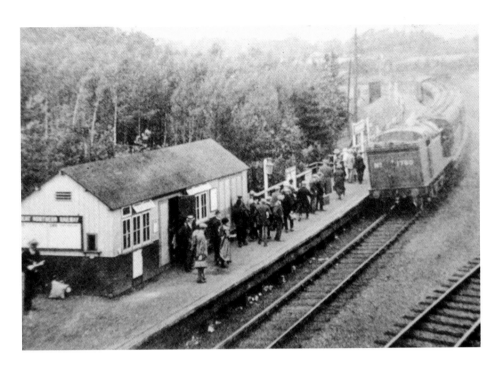

The First Welwyn Garden City Railway Station

Two branch lines left the main railway at the site chosen for Welwyn Garden City, but there was no railway station there. Passengers arriving by the Luton and Dunstable branch or by the Hertford branch, and those who wanted to go north or on to the other branch, had to change at Hatfield. People waved to stop trains on the Luton and Dunstable line. Eventually, a railway staff platform close to the junction on this line was opened to the public. Welwyn station was then renamed Welwyn North. The pictures were taken from Hunters Bridge.

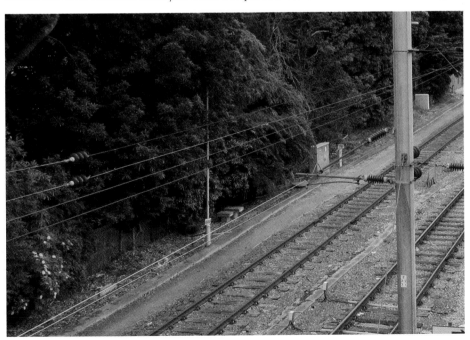

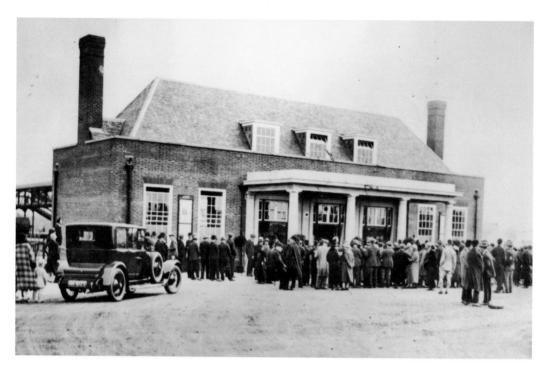

Welwyn Garden City Main Line Station
This station is shown at the time of the opening by Neville Chamberlain in 1926. Instead of having to change at Hatfield, passengers were able to catch main line trains from Welwyn Garden City. Goods were mainly handled at Welwyn North until 1932 (*p. 91*). In 1990, the old station was demolished and the Howard Centre was constructed on railway land.

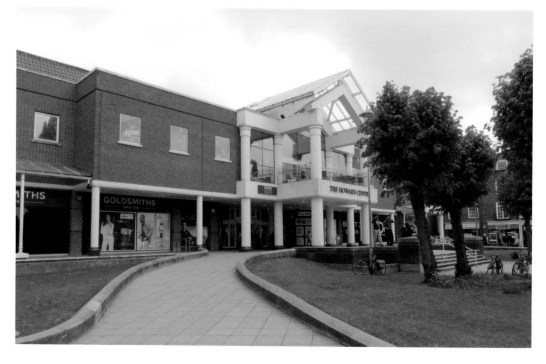

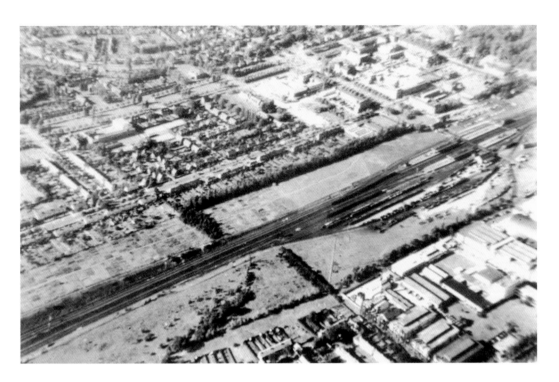

The Great Divide

When the Garden City was first planned, the Great Northern Railway insisted on maintaining a strip an eighth of a mile (170 metres) wide for its use. This, and the Company's locating the 'posh' houses of its directors and officers on the west side, created a social divide; people 'on the wrong side of the tracks' felt excluded. The Howard Centre is just above the centre of the modern picture; Hunters Bridge is in the top right-hand corner.

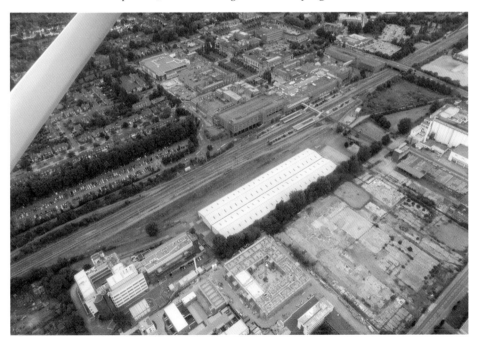

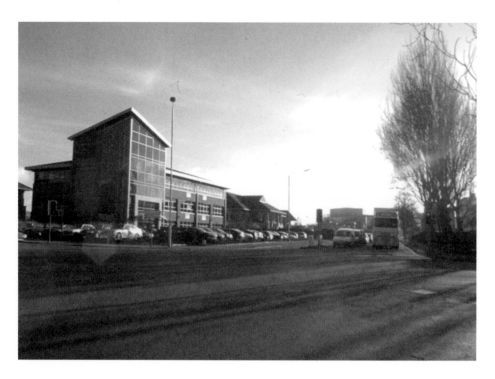

Welwyn Garden City Laundry

Like most of businesses in town, the laundry was a Welwyn Garden City Company monopoly and insisted on being called 'Welwyn Laundry'. Its premises were on the south-east corner of the junction between Bessemer Road and Bridge Road East.

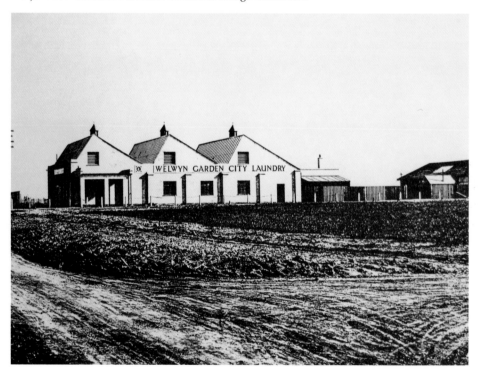

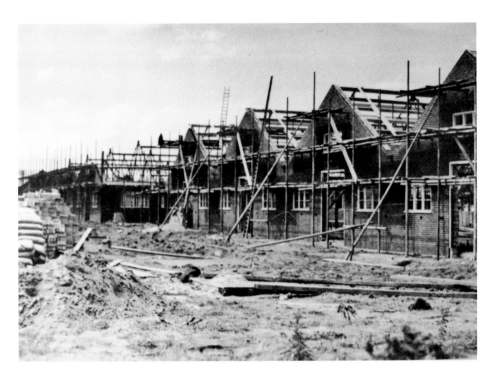

'Units' in Tewin Road

From around 1926, the Garden City Company built sectional buildings, nowadays called 'units': small single-storey buildings, which tenants could sub-divide with their own partitions. Many of these buildings have been replaced (*see p. 36*), but some survive, as here in Tewin Road.

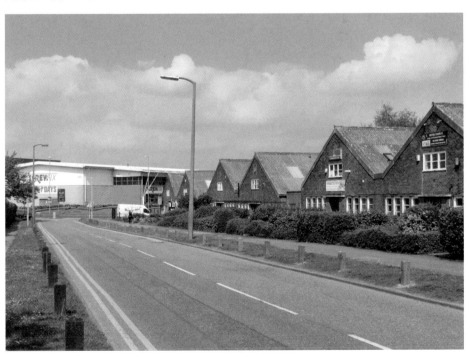

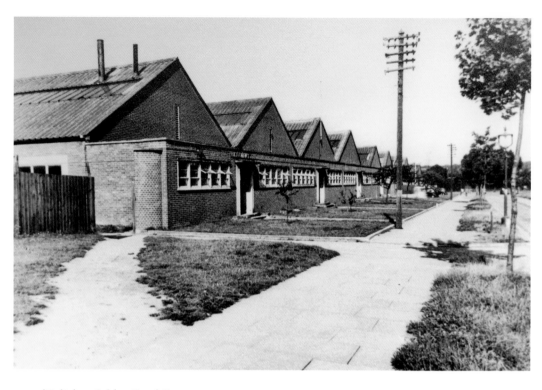

'Units' on Bridge Road East

Many of the units (*see p. 40*) have survived. This row in Bridge Road East has been demolished in recent years and the area developed as housing.

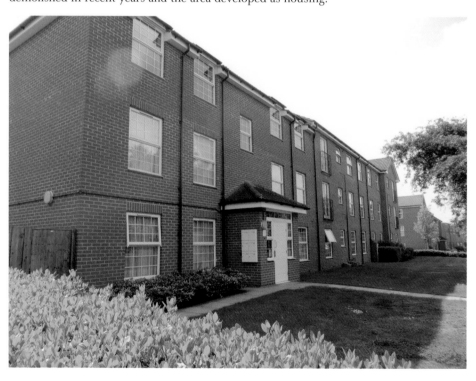

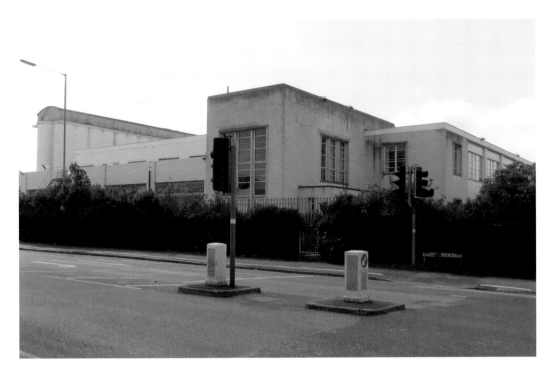

The Shredded Wheat Factory

Today there is debate over whether permission should be given to demolish the listed, gleaming white silos, once familiar on packets of Welgar (from WELwyn GARden) Shredded Wheat. Built in 1925, the factory was taken over by the National Biscuit Company (NABISCO) but has been derelict for some years.

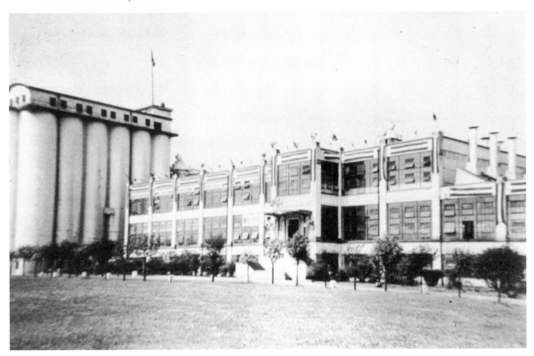

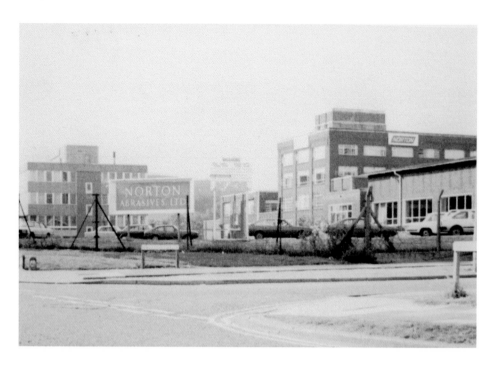

Norton Abrasives

Norton Grinding Wheel, a US-based company, arrived in the Garden City in 1931, and was soon its largest employer, with over 1,000 workers. It built a million-pound office block off Bridge Road East in 1963, but work transferred to plants abroad in 1982. It is still looking for a tenant.

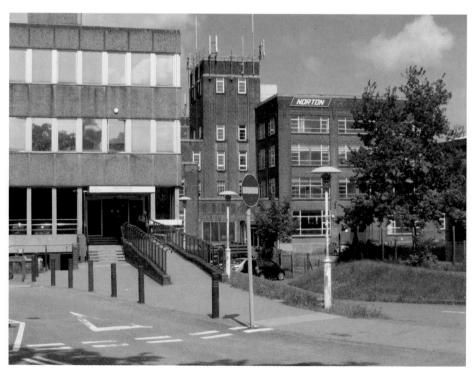

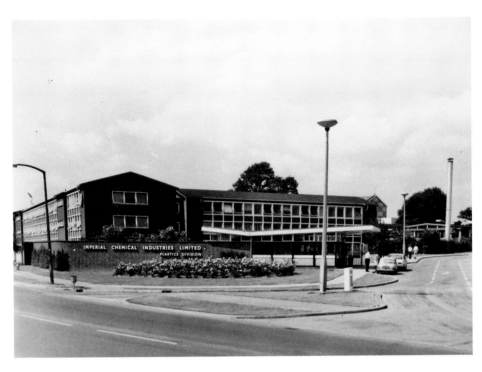

Shire Park

Imperial Chemical Industries new Plastics Division arrived in Welwyn Garden City in 1938. In the 1960s, the firm had about 4,000 employees on a site about 65 acres in extent. After the disappearance of the company in 1998, this was developed into Shire Business Park.

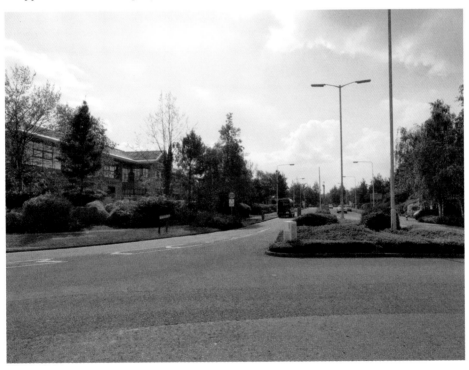

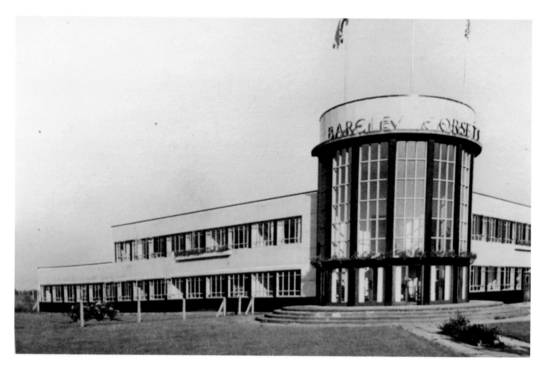

Barclays Corset Factory

This notable example of pre-war architecture stood at the corner of Swallowfields and Bridge Road East. Surprisingly, permission was given for it to be demolished to make way for an undistinguished car showroom.

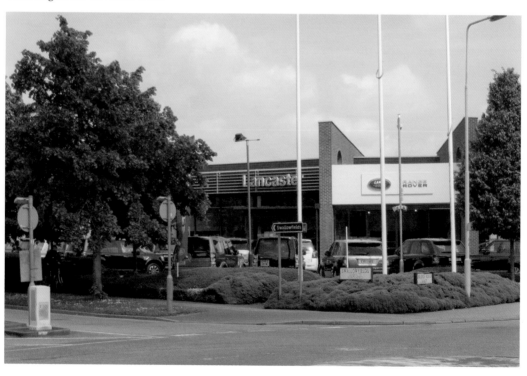

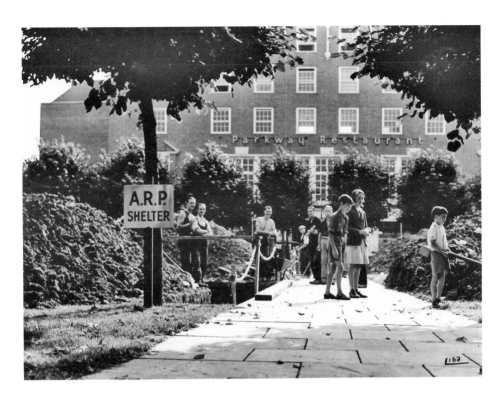

Air-Raid Precautions

In September 1939, the Garden City prepared for a German aerial attack by creating shelters, as seen here, in Parkway. In the background is Welwyn Stores, now John Lewis.

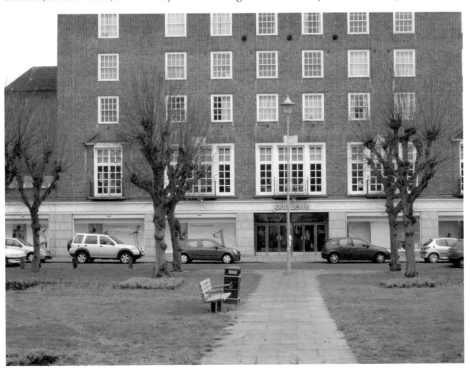

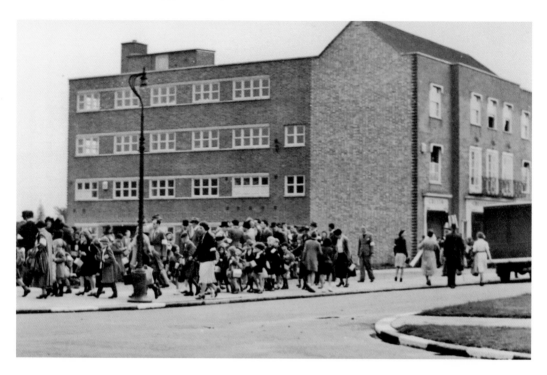

Evacuees Arrive

In 1939, in the first weeks of the war with Germany, about 2,600 refugees arrived at Welwyn Garden City station. At this time, the building on the right of the picture belonged to Cresta Silks. Its corner is left serrated for the future extension, which has taken place in the modern picture.

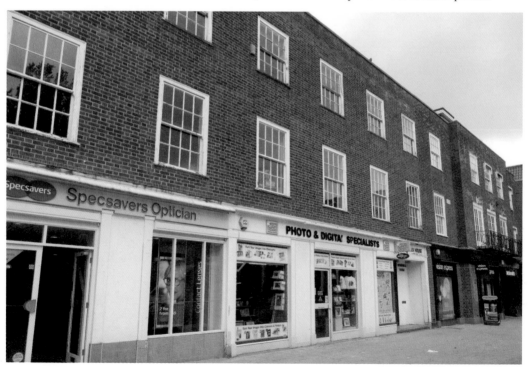

Enemy Action at Coneydale

At the beginning of hostilities in 1939, Coneydale was the northern boundary of Welwyn Garden City. In October 1940, a bomb damaged two houses so badly that they were not repaired. This was to be a blessing to the planners when the new Digswell road was planned, because it provided a ready-made gap for it.

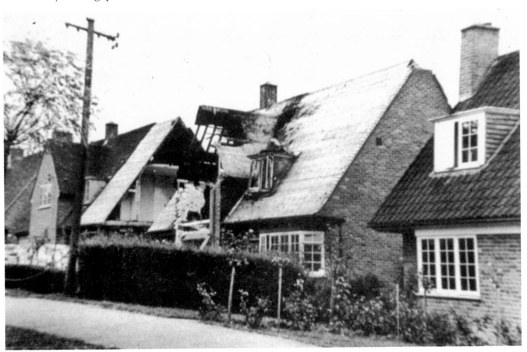

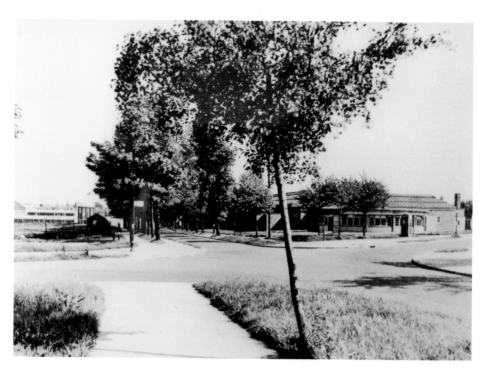

The Junction of Bridge Road East and Peartree Lane

On the right in the older picture, the British Restaurant can be seen, which provided economic and healthy food during the war. It closed in 1955. On the left in the distance is the Barclay Corset factory (*see p. 40*).

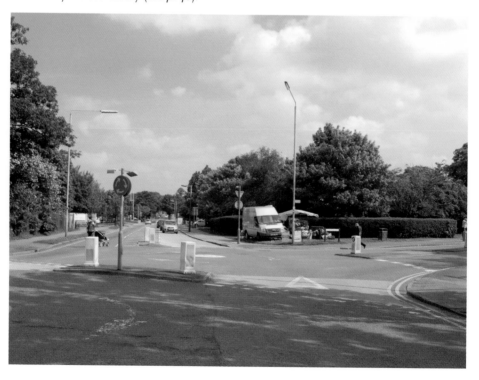

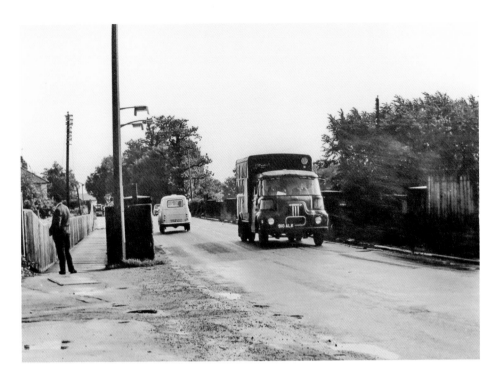

Twentieth Mile Bridge

This bridge was so-called because it is at the mile marker on the Great Northern Railway, 20 miles from Kings Cross. The fact that, like Hunters Bridge, it was doubled in size emphasises the original division of the Garden City by the main line.

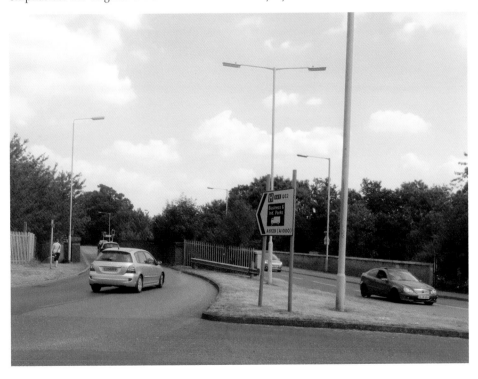

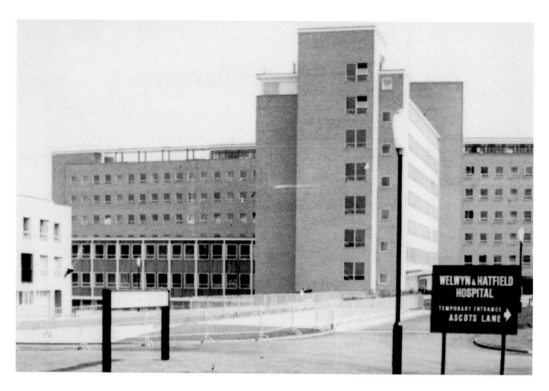

Queen Elizabeth II Hospital

The first complete hospital to be built by the National Health Service is usually referred to as 'The Cue-ee-too'. It was opened by Her Majesty the Queen (who is *never* referred to as cue-ee!) in 1963. It grew from a 350-bed district general hospital, but is being closed and demolition has begun.

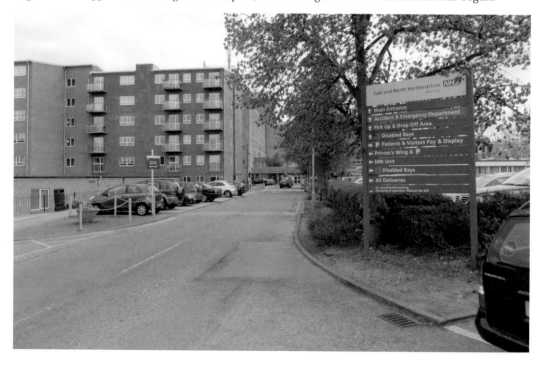

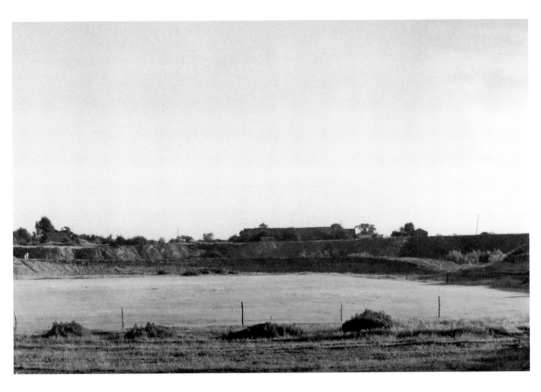

The Gosling Stadium
The Stanborough gravel pit was once used to train bulldozer drivers. The area has now been developed in to the 50-acre sports and leisure centre, Gosling Sports Park.

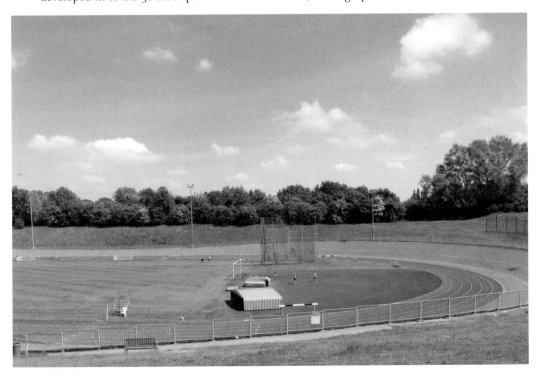

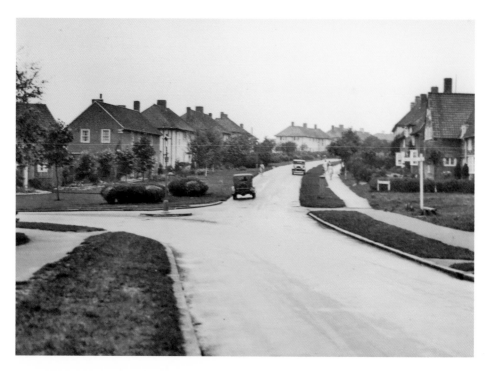

The Junction of Brockswood Lane and Valley Road
Streets given the name 'lane' in Welwyn Garden City were original farm tracks. It was in this area that the construction of the town began. It is of particular note how the landscape has altered in the ninety or so years since the first picture was taken.

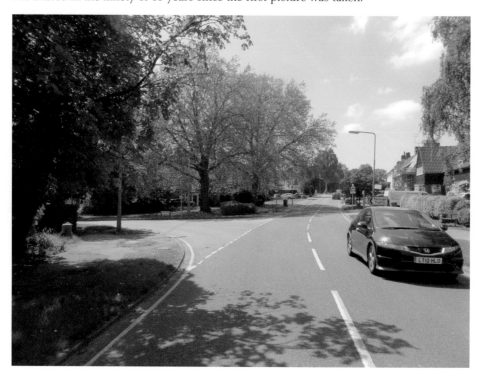

Pear Tree Lane

The original poor-quality houses in Pear Tree Lane were constructed of poured concrete, which cracked and had poor thermal insulation. They have been replaced with brick.

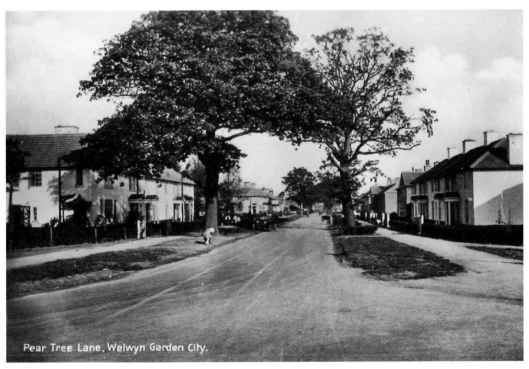

Pear Tree Lane, Welwyn Garden City.

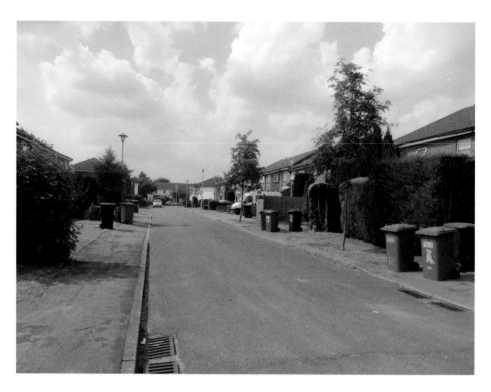

Goblins Green

The houses in Goblins Green, between Broadwater Road and the railway, were substandard, like those in Peartee lane (*p. 49*). They were demolished and replaced in brick. At the same time, the street became a cul-de-sac.

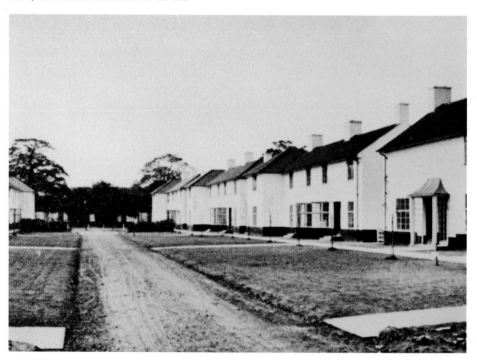

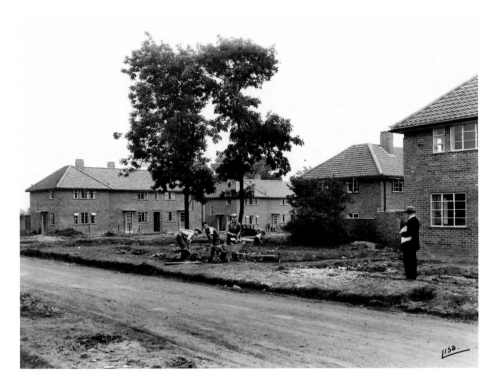

The Thousandth House

The house in the foreground, right, is in Longlands Road; those in the background are in Ludwick Way. Second from the right, behind the bush in the first picture, taken in 1938, is the thousandth house built in Welwyn Garden City.

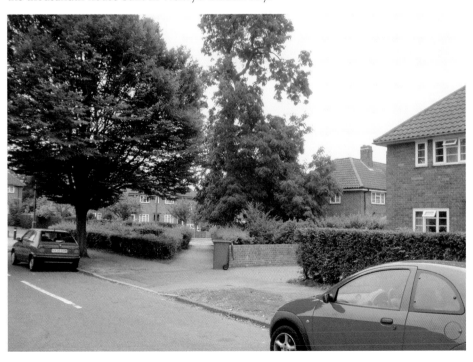

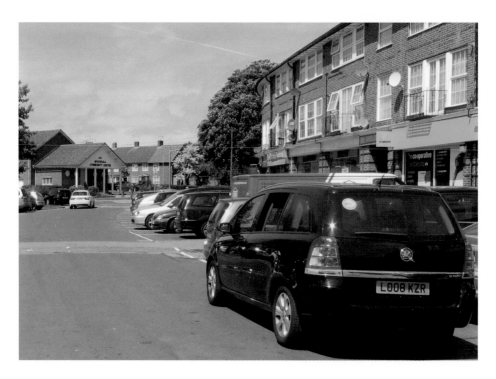

Woodhall Parade
This was built before the war as Cole Green Lane shops. The place was renamed from the farm (which still exists) about a mile distant to the south. All the major banks had branches there. Woodhall Community Centre can be seen in the background.

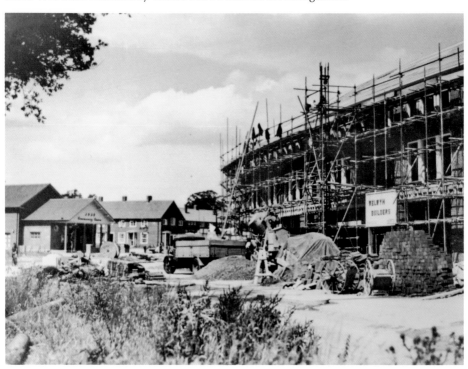

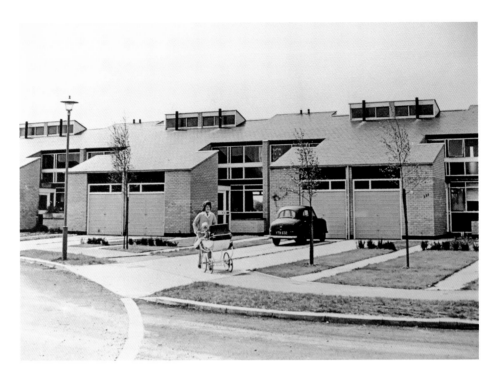

Daniels

This road in the (historically misleadingly-named) Panshanger estate was developed in the second half of the 1960s, with houses built for sale. Close to here, the famous Iron Age Chieftain Burial was excavated.

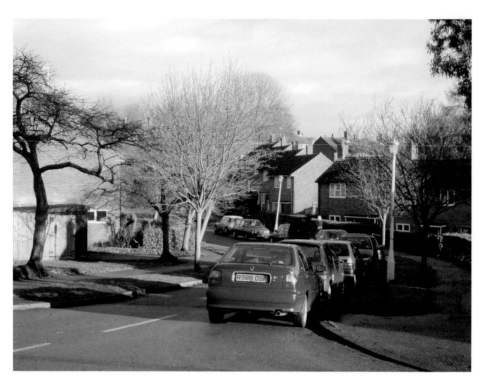

Vineyards
It is fascinating to see the transformation from building site in the 1950s to the completed residential street in 2012.

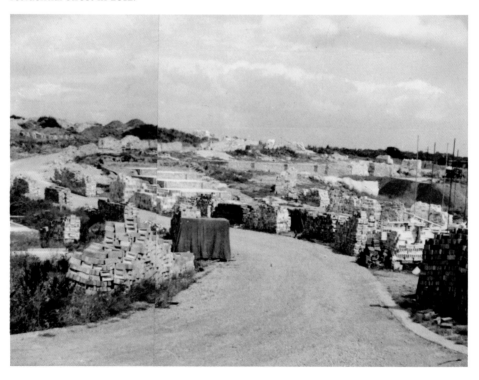

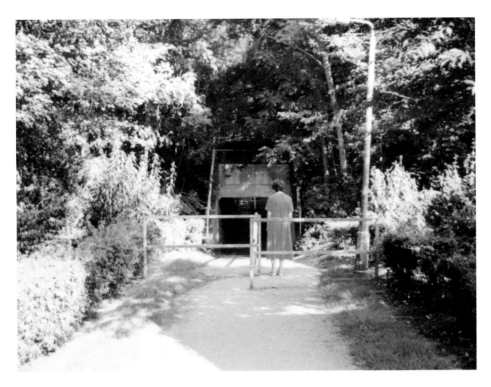

Digswell Road Underpass

When Digswell Road was constructed, a pedestrian underpass was made to allow residents from the Harwood Hill estate to get to Shoplands. The softening effect of tree planting is emphasised here.

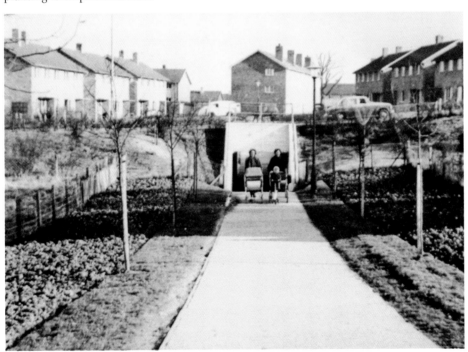

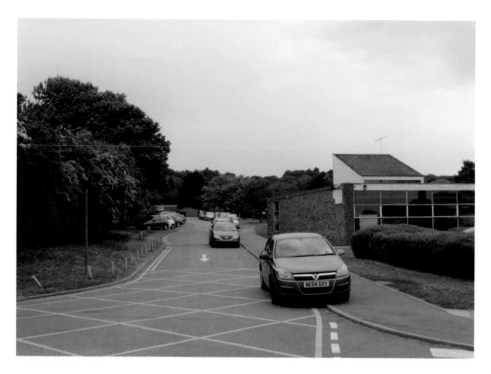

Monk's Walk School

The school, which takes its name from the nearby avenue, was built on arable land in the 1960s and has since grown to the size of a small town. The houses in the background of the first picture are in Crossway, formerly The Avenue – which was always known locally as 'The Row o' Trees'.

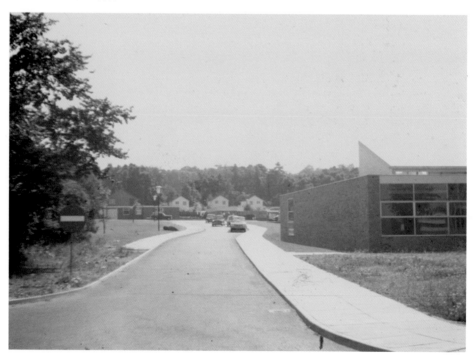

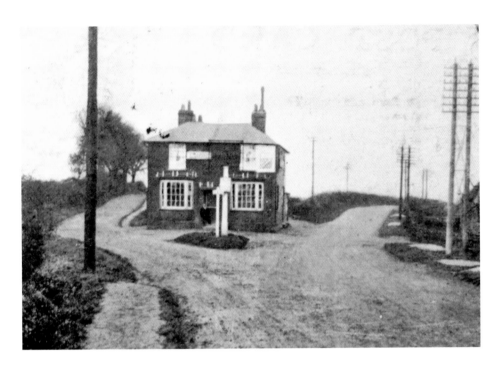

The Bull, Stanborough

The Bull stood between the Old Great North Road, which went via Lemsford Mills (*p. 58*) and New Road, which was created by MacAdam at the beginning of the nineteenth century. After Stanborough Road became the way into the Garden City, a new Bull was constructed on the other side of the Great North Road. The road layout here was completely changed when the motorway was constructed.

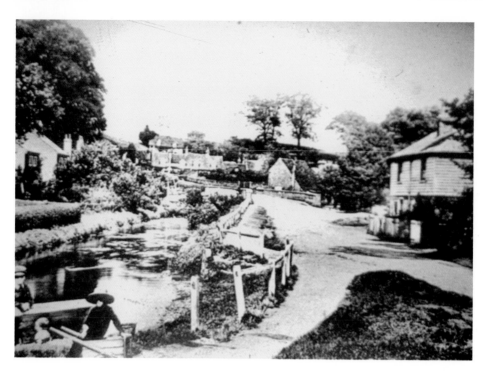

Lemsford Mills

The original Great North Road consisted of a number of minor roads. It forded the Lee at Lemsford Mills and went (as 'Brickwall Hill') up the side of Brocket Park. This stretch of road was bypassed in 1934 by New Road, which began at The Bull, Stanborough (*see p. 57*), and ended at Ayot Green. This was downgraded when the motorway was constructed (*see p. 59*).

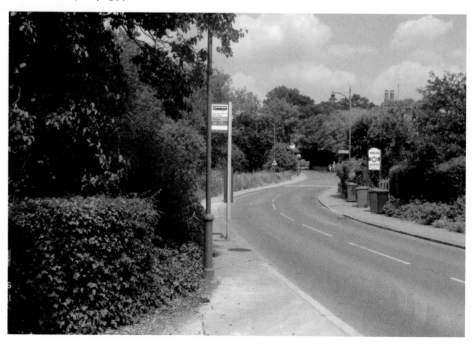

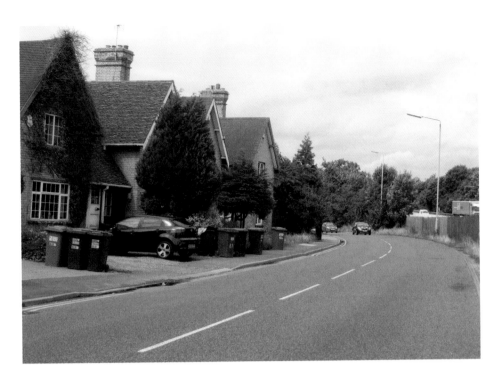

Estate Houses Near Lemsford

These typical Cowper estate houses were built beside the New Road (A1), Lemsford, for the Brocket Estate in 1891. The road is now downgraded and the whole of the right-hand side of the modern picture is taken up by the A1(M) motorway. Traffic can be seen behind the fence.

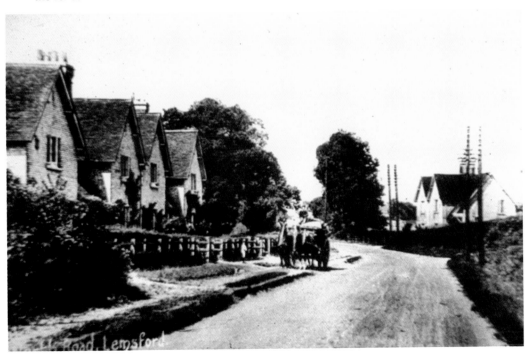

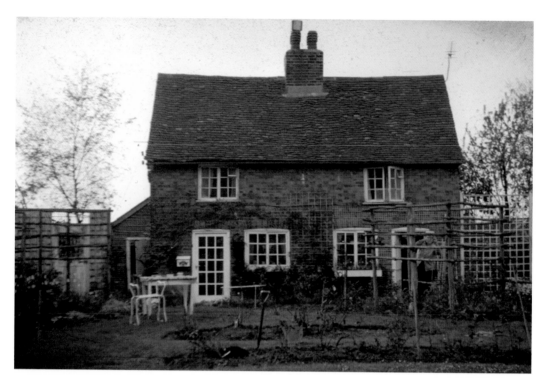

Mrs Trench Watson's Cottage

The construction of the motorway brought destruction to many buildings in its path. A sad example was this cottage near Ayot Green. The Red Lion (*p. 61*) can be seen in the background of the modern picture.

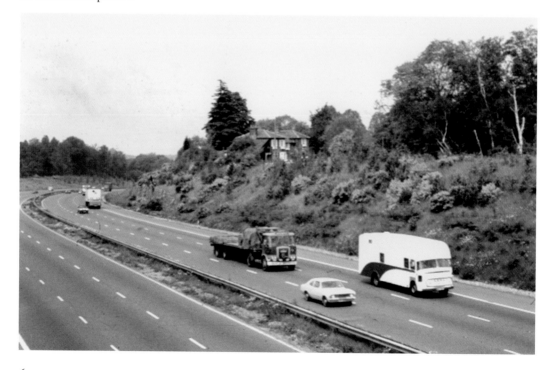

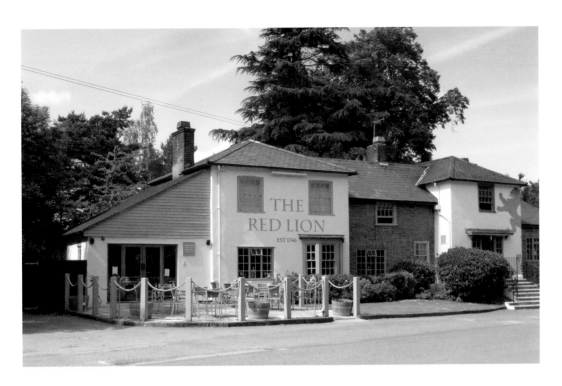

The Red Lion, Ayot Green

Originally, this eighteenth-century pub was The Shoulder of Mutton, built on waste land beside the Great North Road. Its name was changed when the Red Lion in the village ceased to trade. The lean-to part at the left was the forge. The pub now has a large car park, part of the old A1 road cut off by the A1(M) motorway.

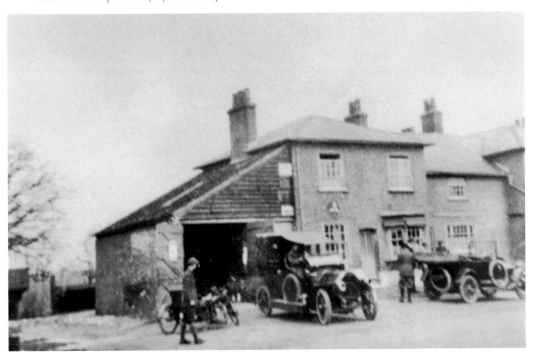

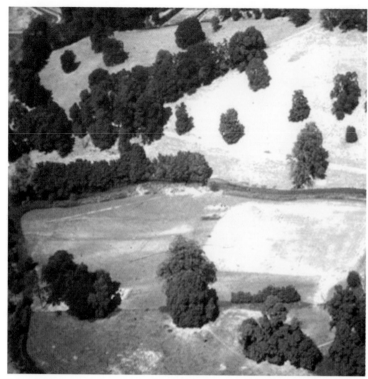

Dicket Mead Roman Villa

In 1960, I discovered Roman roof tiles exposed by erosion of the river bank, close to the row of trees across the centre of the picture, and started an archaeological training dig that I continued to direct for twelve years. A 'grid' of trenches can be seen under the trees in the left bottom corner. The A1(M) was built across the site, covering part of it under an embankment.

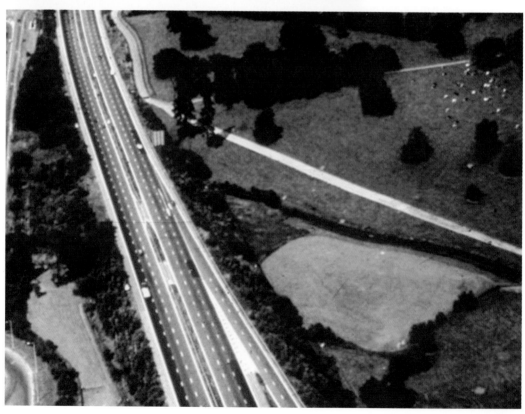

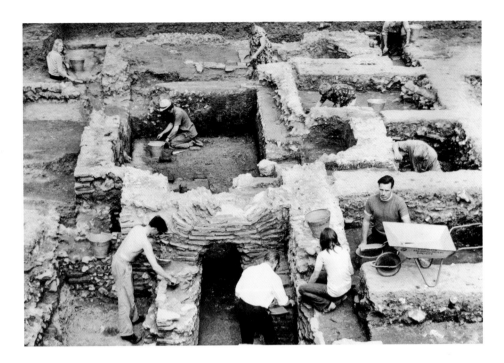

Welwyn Roman Baths

The team excavating Dicket Mead Villa became Welwyn Archaeological Society, and in 1969, in one of the villas, two suites of baths were discovered. As this was on the line of the proposed motorway, I launched a campaign which resulted in these baths being preserved in a corrugated steel vault inside the motorway embankment. Initially opened to the public by the Welwyn Archaeological Society, the site is now operated by the Welwyn Hatfield Museum Service.

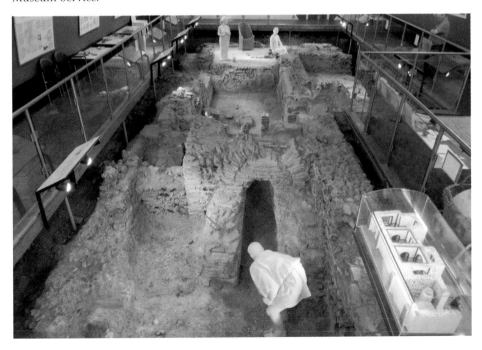

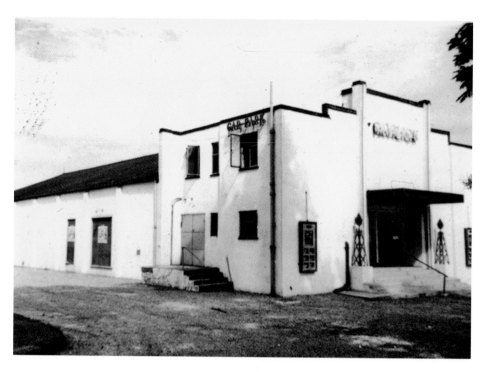

The Pavilion Cinema

Welwyn's purpose-built cinema was opened in 1938, between London Road and the bypass. It closed in 1961, and became an Acland and Tabor's car distribution centre. It was taken over by Ford and Godfrey Davis. In 2004, the whole area was developed as a housing estate called Nodeway Gardens.

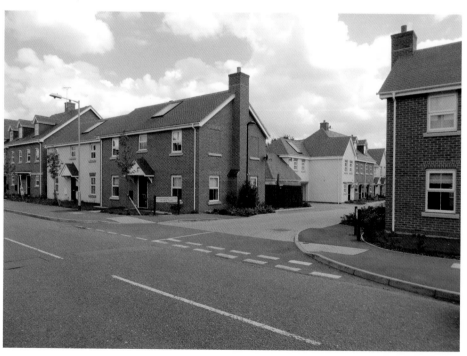

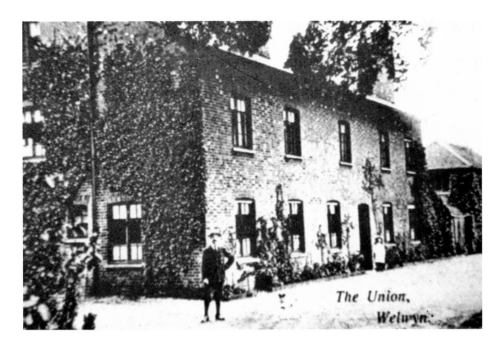

The Union, Welwyn.

The Workhouse

In 1723, workhouses were created that seemed to act as houses of correction as well as workhouses and poorhouses. Their main inhabitants were the unemployed, mainly those too old or infirm to work. Welwyn Poor Law Union was dissolved in 1921, and the workhouse was used as a children's home for the Hatfield Union until 1924. The buildings have now been adapted for residential use.

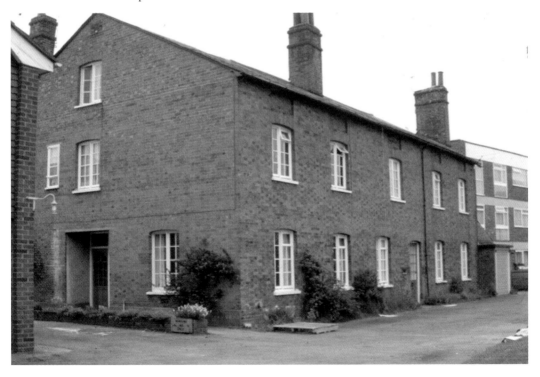

St Mary's School, Welwyn

The Church of England school opened in 1858 with ninety boys, seventy girls and sixty infants. A new senior school was opened behind it in 1940. In 1985, the infants and juniors were moved into this and the seniors were transferred to Monk's Walk comprehensive school. The watercolour picture was painted by Kate Rook on the last day, and copies are to be found all over the world.

Welwyn Drill Hall

The hall is also called Becket Hall from the inscription across the front. With its associated buildings, it was built in 1878 by C. W. Wilshere of The Frythe for the local militia. It was used for services when the church was being restored.

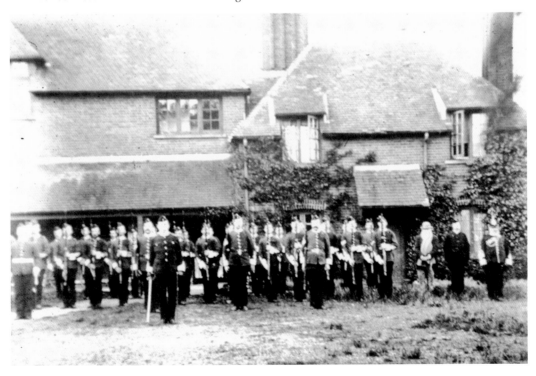

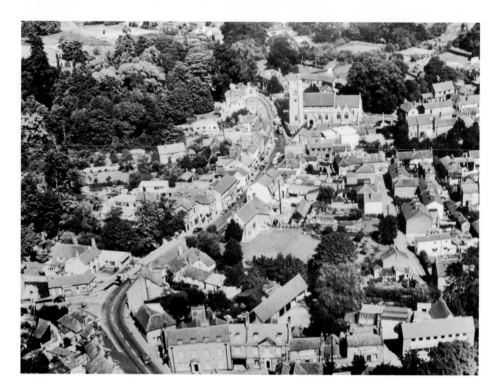

Welwyn Village from the Air

These views are taken looking along the High Street towards the church from the south. The White Hart is in the foreground. In the 1960s, the area on the west side contained a number of small businesses. Today it is a housing estate, Mimram Place. In Mimram Road (centre), small timber-framed clapboard houses in the first picture are replaced by an old persons' bungalow in the second.

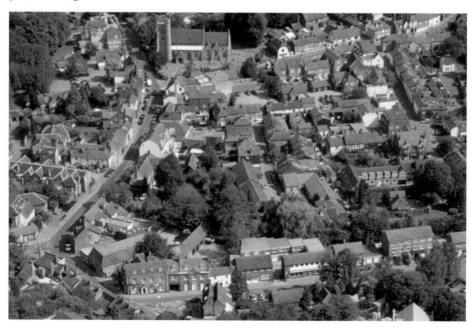

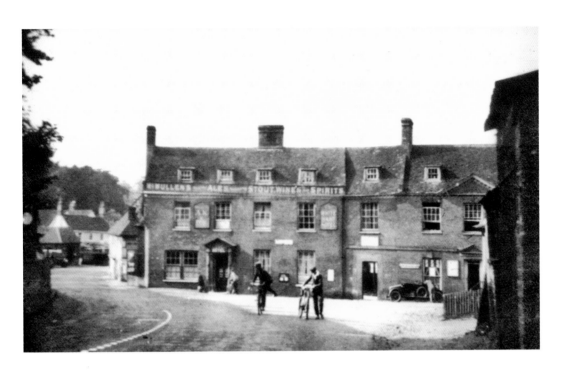

The White Hart

This inn encapsulates the fortunes of Welwyn. It was a substantial timber-framed house until 1675. It was then converted to a coaching inn. This was enlarged on the right by the addition of the court house downstairs and a banqueting chamber above, and a brick front was added around 1800. Before the railway came in the mid-nineteenth century, it was said that the inn provided horses for 'upwards of eighty coaches per day'. At some point, the carriageway was blocked. The parapet wall was added in the 1930s and the carriageway reopened.

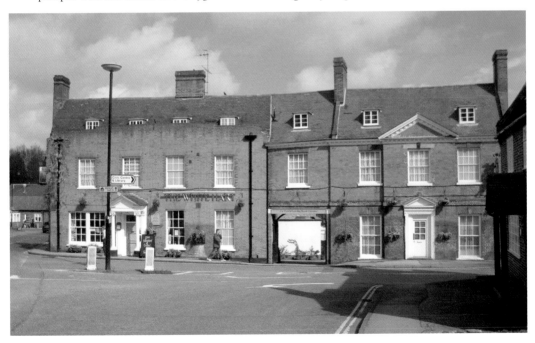

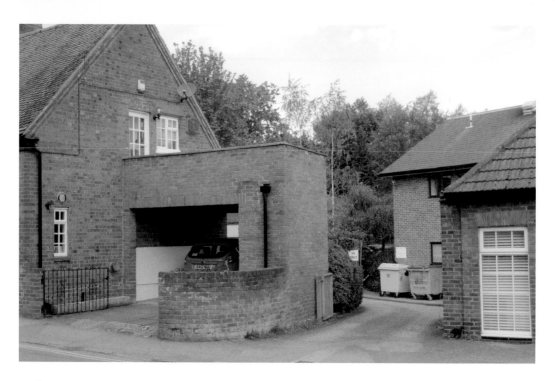

Welwyn Brewery

A brewery was operated by Mew & Co. behind what is now the doctors' surgery. Most of its output was destined for the large houses in the district, and it only owned one 'tied house': The Fox in Woolmer Green. The brewery was bought by McMullen and operated as an off-licence until 1947.

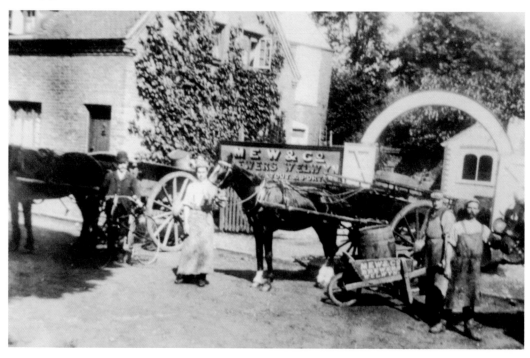

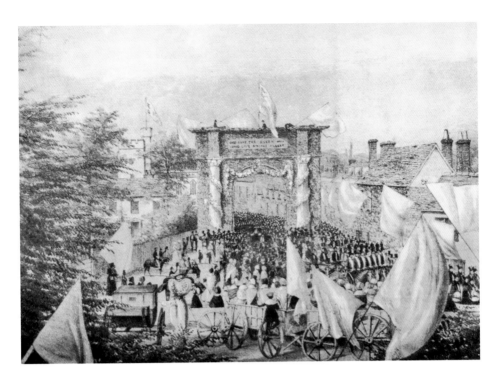

The Visit of Queen Victoria

Queen Victoria and Prince Albert went through Welwyn Village when they visited Panshanger in October 1841. A temporary triumphal arch of flowers and greenery was erected at the south end of the bridge to greet the royal couple.

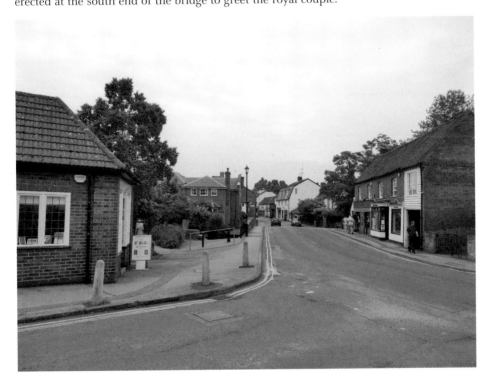

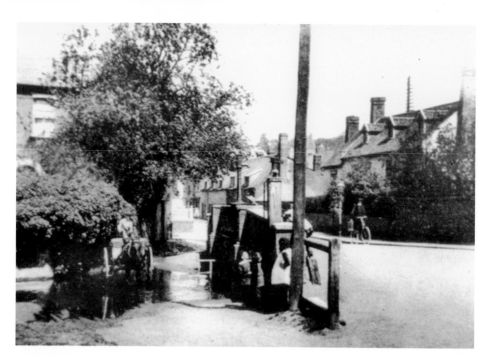

The Ford at Welwyn

Welwyn grew when coaching became common in the seventeenth century, as it was a place where the River Mimram could be forded, providing the Great North Road with access to the Roman Road at the church. The bridge was a later construction. Note the fittings for water pumps.

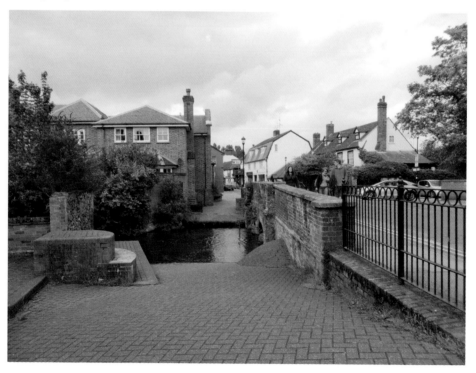

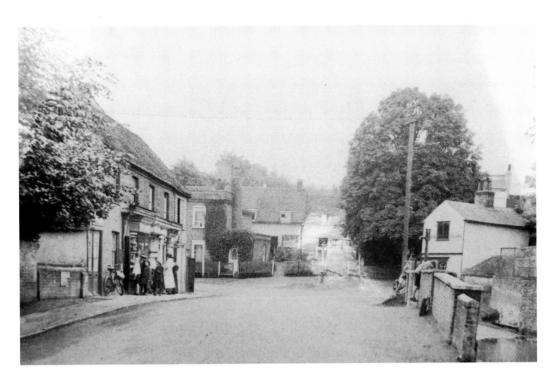

The Mimram Bridge, Welwyn

The bridge was built beside the ford, probably at the end of the eighteenth century, and was later widened, probably by MacAdam in the early nineteenth. A curious fact is that the river goes in three arches and comes out of two! Note the pumps in the pictures.

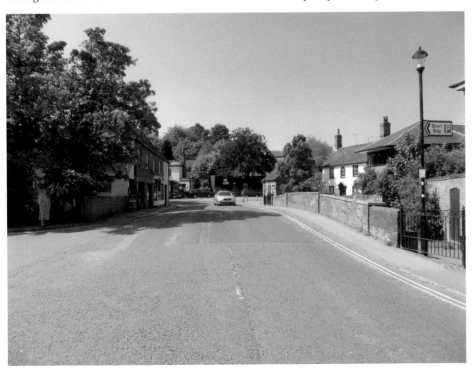

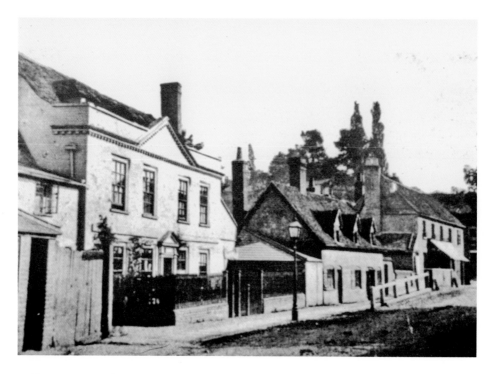

Bridge House, Welwyn

Bridge House occupies the site of an inn called The Dog. When the old photograph was taken in 1872, the house was a post office. Several local buildings have served as post offices at different times.

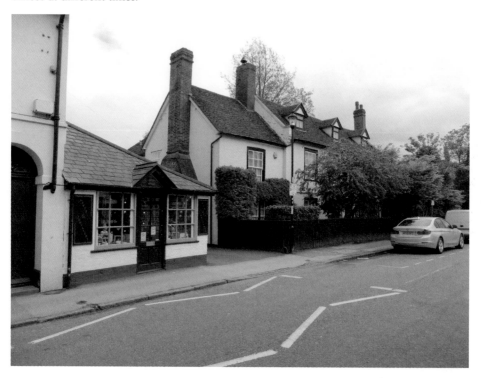

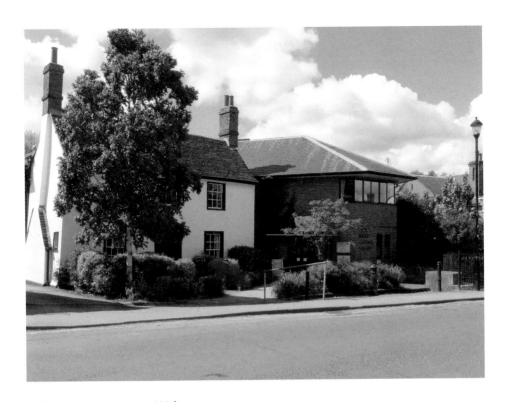

Bridge Cottage Surgery, Welwyn

Bridge Cottage was described by Pevsner as 'attractive but with an ugly extension' – the Welwyn doctors' surgery, said to have been mistaken by visitors for a fish and chip shop. The extension was replaced as the population and the practice grew.

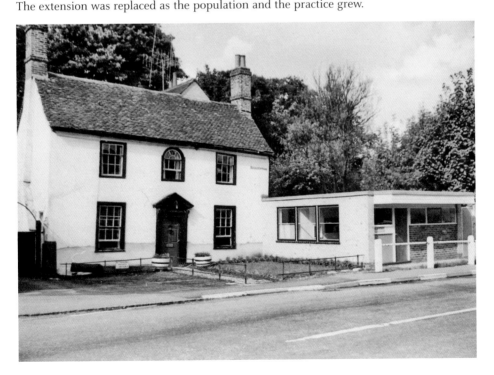

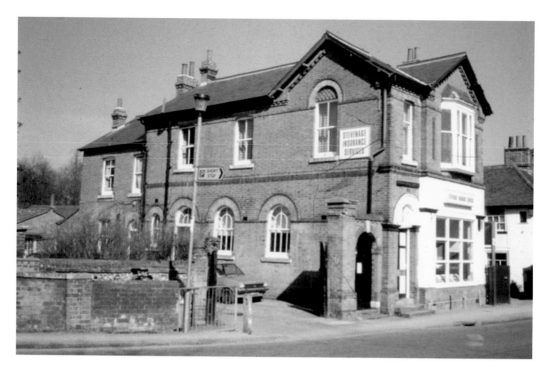

Welwyn Main Post Office

Seven buildings have taken turns to be the post office in the village. In 1897, George Storthard was responsible for the first purpose-built office, which was the central GPO for mid-Hertfordshire. After the business was transferred to Welwyn Garden City in the 1930s, it had several uses, but was demolished when the area between the High Street and the river became a housing estate.

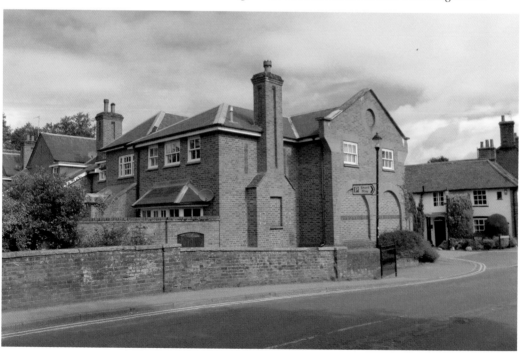

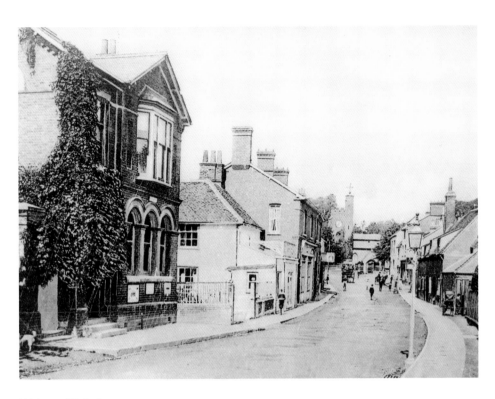

Welwyn High Street

The earlier view shows the church with the red-brick century tower and low nave roof, which were replaced in the 1911 restoration (*see p. 81*). On the left is the old post office, which was demolished when Mimram Place was constructed.

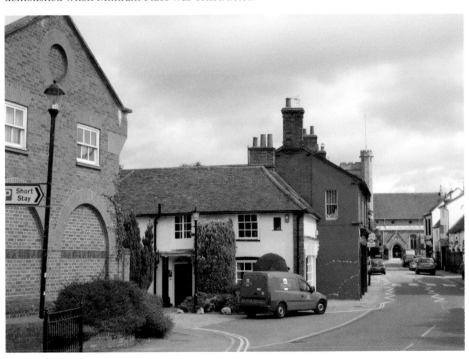

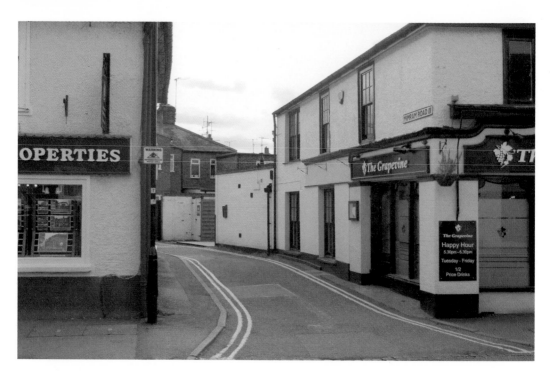

The Black Horse and The Boot

Welwyn Village has been blessed by public houses, beerhouses and inns; at least nineteen licensed premises existed, though not necessarily at the same time. Three of them appear in the modern picture: The Boot on the left, The Black Horse on the right, and The Moorhen in the distance.

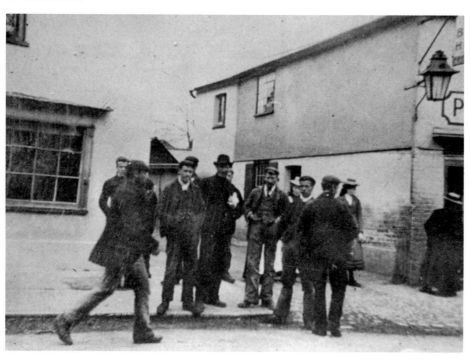

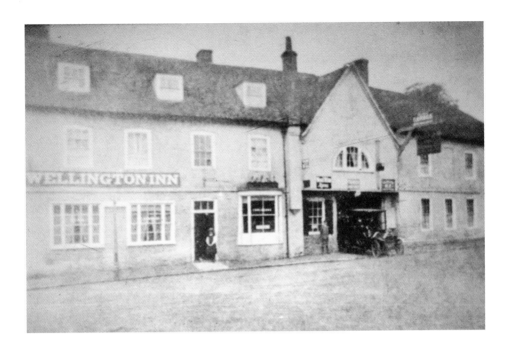

The Wellington

The north end of this building is possibly the oldest public house in the village, called The Swan, which was joined to the public house next door, The Boar's Head, in 1646. The join can be seen in the roof line. It was given a 'modern' false brick front in 1729, and although it does not seem to have become a successful coaching inn, it had stabling for twenty-four horses. It was renamed after the Battle of Waterloo. In the old picture, the motor car is coming out of the carriageway that led to the village smithy.

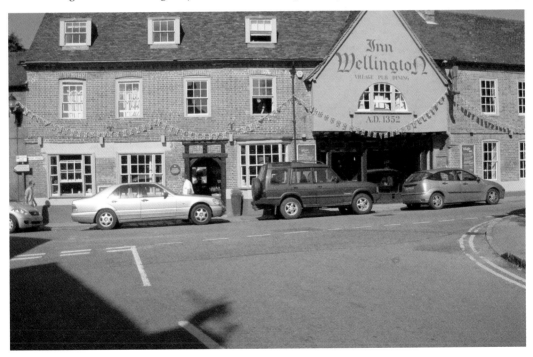

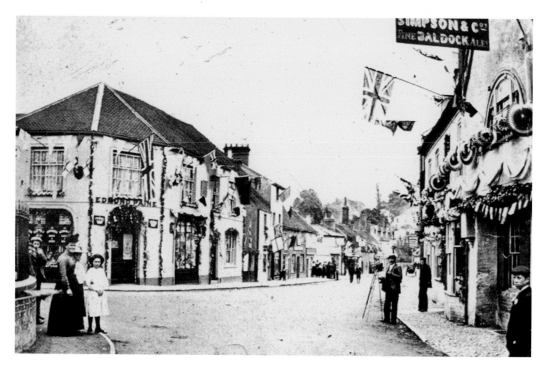

The Coronation of Edward VII

This picture was taken looking south down the High Street from outside The Wellington. Unusual pleasure is derived from the fact that on the back of my copy someone wrote, at the time, details including the names of people. The larger boy in the right-hand corner married the girl on the left!

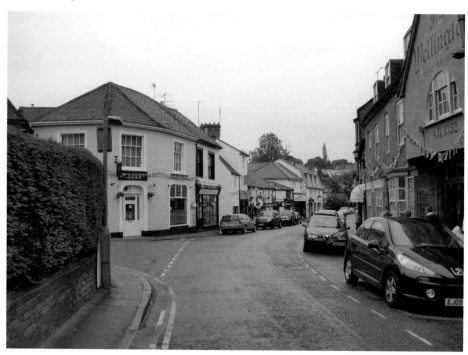

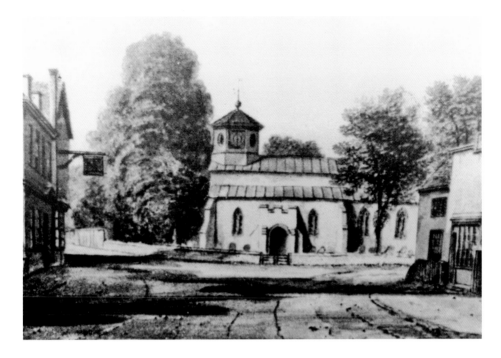

St Mary's Church

The structural history of Welwyn church is unusual. An early structure was ruined in the seventeenth century when the tower collapsed. In the eighteenth century a belfry was constructed, as shown in the Buckler watercolour. A new brick tower was built in 1839 and can be seen in the picture of the High Street on page 77. A new chapel and chancel were built in 1869. The present nave and tower are dated 1911.

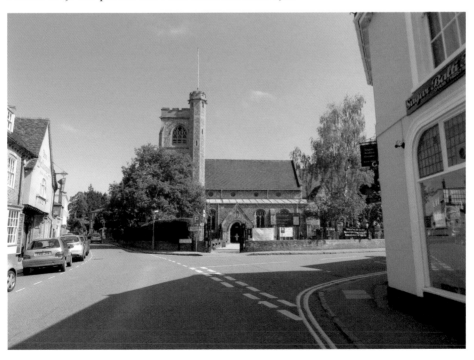

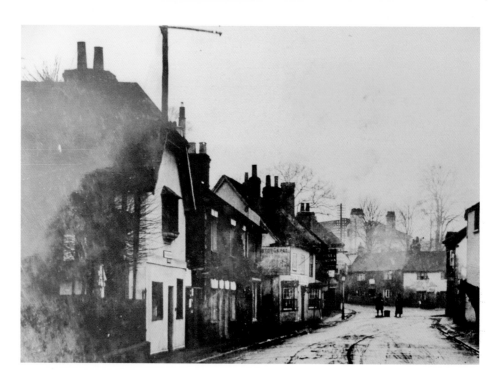

Church Street, Welwyn

Traffic following the Great North Road turned right at the church and went up Church Street, joining the line of the Roman Road towards Robbery Bottom. Church House, the timber-framed building on the left of the picture, built in the late fifteenth century, was the Police Station in the nineteenth century. The large house at the end of the street was Wendover Lodge.

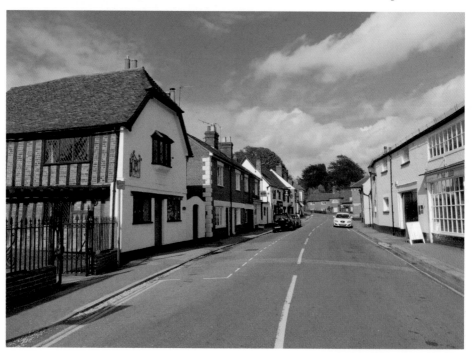

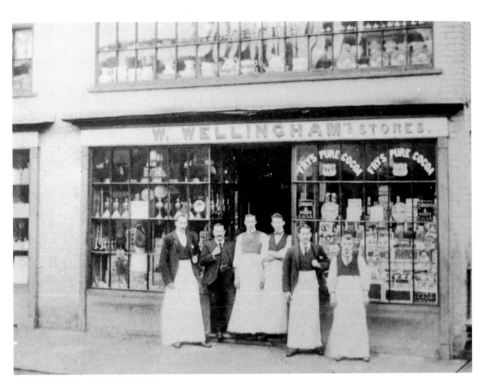

Wellingham's

This fine shop was built as a grocer's (downstairs) and hardware shop (upstairs), and continued as the largest grocery store in the area until the 1960s. It is now a ladies' hairdresser.

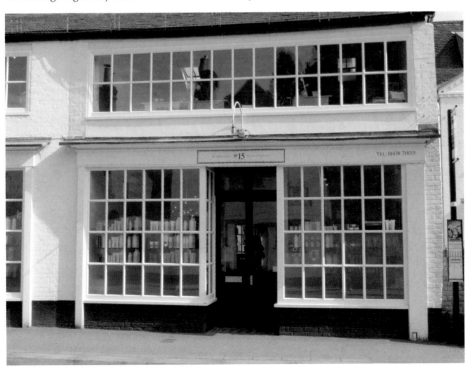

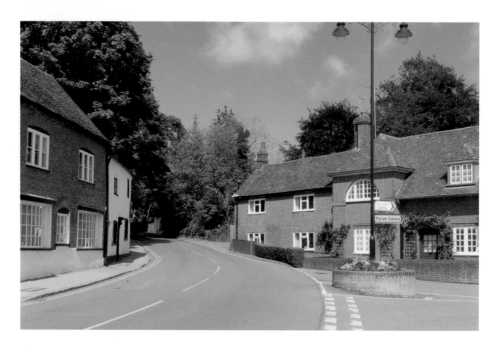

The East End of Church Street

The island flowerbed is where one of the village pumps once stood. On the left is The Chequers pub, fronting onto the Stevenage Road. The left-hand cottage belonged to the basket maker. The ivy-covered cottage next to it was once a pub called The King William IV, standing beside what was the Hertford Road until around 1720, when it became the Drive to Lockleys. The cottage was replaced by the red-brick lodge for Lockleys, designed by Lutyens. Only one brick pier of the original gates of Lockleys survives.

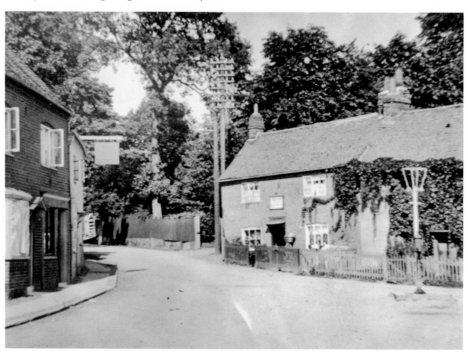

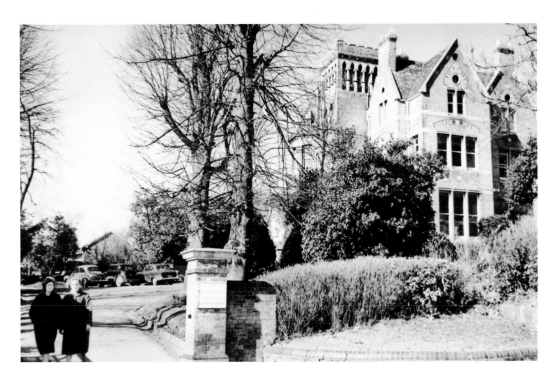

Welwyn Hall

Originally named Myrtle Hall, this amazing polychrome Gothic house was built as a dower house for Danesbury. It was used as laboratories by ICI Plastics, and then by other organisations who built the research laboratories in the grounds, where I used to work. The hall and other buildings were demolished to make way for a housing estate.

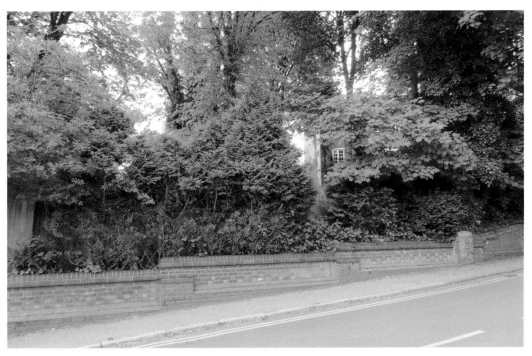

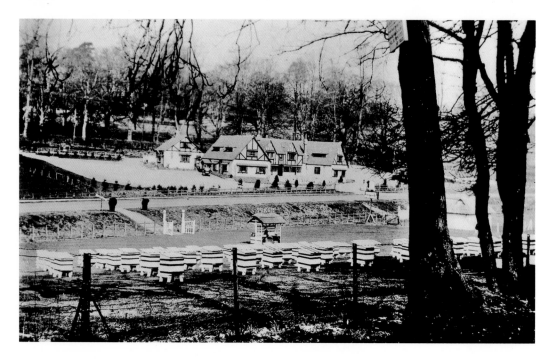

The Clock

The Clock was a popular 'roadhouse' beside the Great North Road, with its own swimming pool, which had ceased to be used around twenty years before the link road from the Codicote Road to the Clock Roundabout destroyed it. The building became a motel and was extended, with a clock tower (visible in the recent picture), after the motorway was opened. The site is now dilapidated and planning permission is sought to build flats on the site. Opposite the Clock, a notable landmark was the monstrous regiment of beehives.

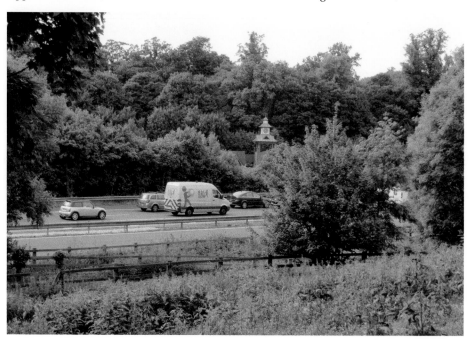

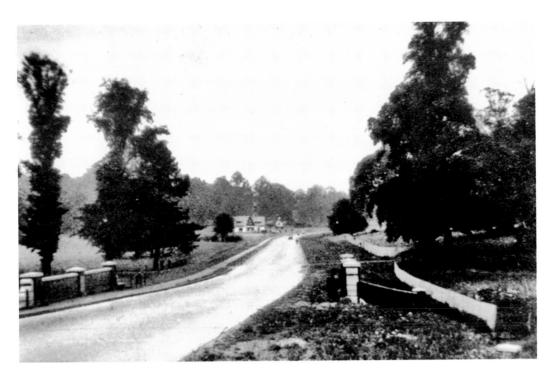

Welwyn Bypass

By the 1920s, there were problems caused in Welwyn Village by the shear volume of road traffic and by the vehicles on the Great North Road having to cross it going to Bedford; at busy times, there was a policeman on point duty outside the church gates! One of the first bypass roads in Britain was opened at Welwyn in 1927. It has been widened and partially rerouted at its northern end to join the motorway.

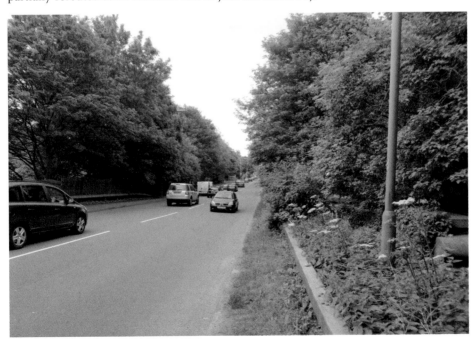

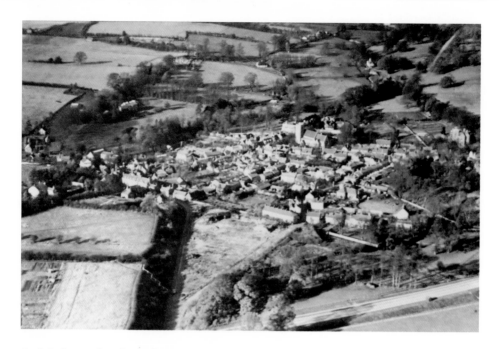

Aerial Views of Welwyn from the East

The most remarkable thing is the diminutive size of Welwyn at this time, when it was the main administrative and commercial centre of mid-Hertfordshire. In the foreground of the picture, taken around 1927, is the new bypass, with no traffic. In the centre is the great triangular hole, Prospect Place, produced after the new Hertford Road was created twenty years earlier. In the modern picture, it has been filled by the fire station, telephone exchange and Civic Centre, which has a green roof.

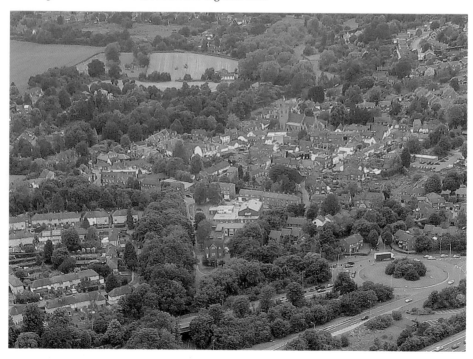

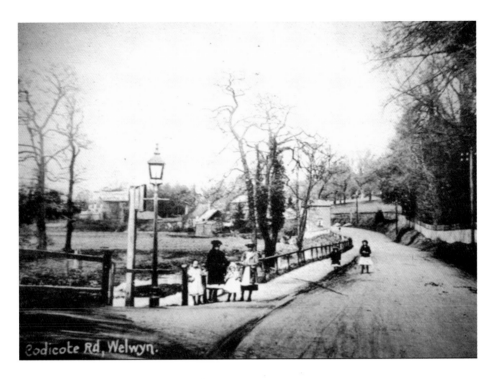

The Codicote Road at Singlers Bridge

The bridge leads over the River Mimram. It is tempting to look back to the idyllic days before traffic calming and street furniture. However, the expectation of life for these little girls was short. At the time the early photograph was taken, the river was polluted with human waste and Welwyn Village, downstream, was 'very offensive when the mud was exposed'.

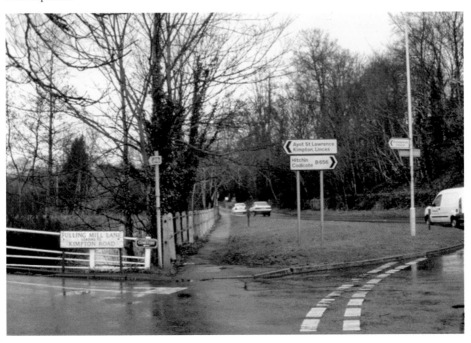

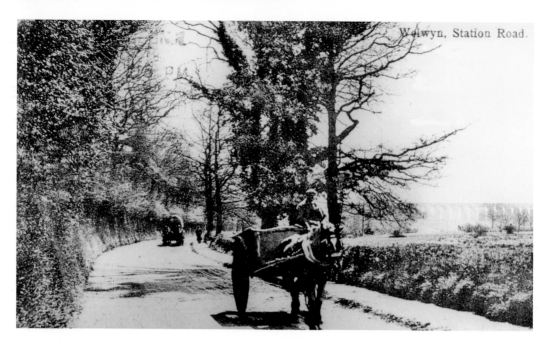

Welwyn, Station Road.

Station Road

This road is now Hertford Road. The magnificent elm trees were destroyed when it was upgraded in the 1970s and turned into a dual carriageway. A large roundabout was constructed where Bessemer Road joins it.

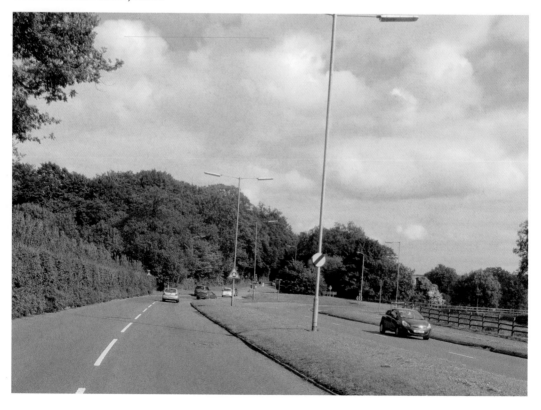

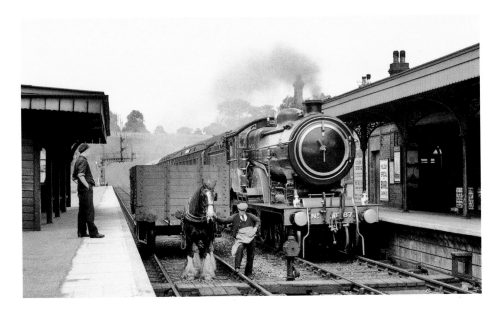

Welwyn North Station

Welwyn was the administrative and commercial centre of mid-Hertfordshire and, after 1851, Welwyn railway station became the major centre for goods. There were sidings on both sides of the line. Shunting was done, literally, by horse power! The last shunting horse retired in the late 1940s. The name of the station was changed to Welwyn North in 1926, when Welwyn Garden City's main line station was opened (*see p. 32*). When it was built, half the station was in Digswell parish, and, although the area is always called 'Digswell' by local people, a proposal to give the station that name was recently rejected in a local referendum. (The magnificent steam engine and horse are published by kind permission of Brian Stephenson.)

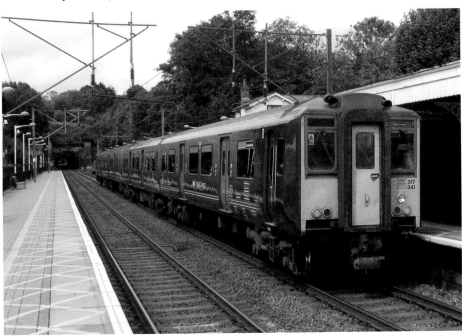

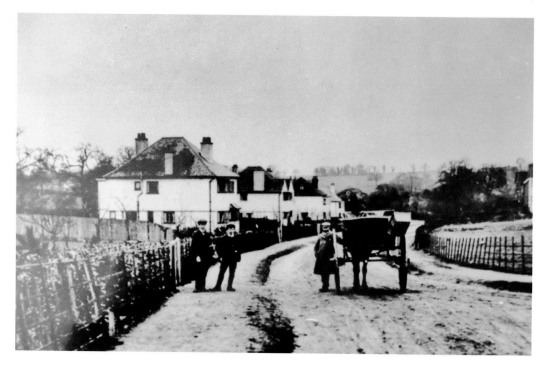

Station Road

The present Station Road, Welwyn, shown here on a postcard labeled 'High Welwyn', is at the centre of a controversy of local place names. To many it is in Digswell, but at the beginning of the twentieth century, even before Welwyn Garden City was conceived, the area between the Hertford Road and Harmer Green was being developed by High Welwyn Ltd. The development involved the construction of New Road.

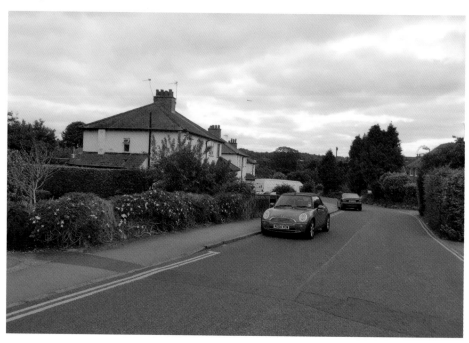

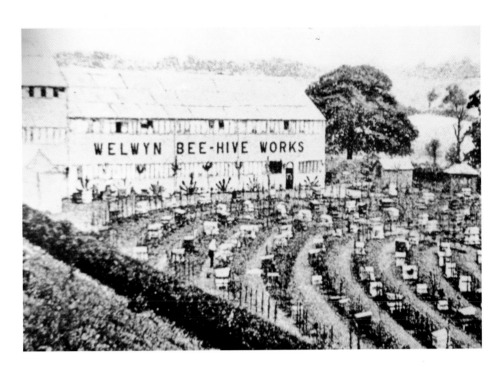

The Beehive Works

Welwyn was once famous for apiary equipment, especially beehives. From the 1930s until the early 1960s, a regimented field of white-painted hives was one of the landmarks for travellers on the Great North Road (*p. 86*). The factory manufacturing the hives was also a notable feature beside the railway by Welwyn North station. It has now been replaced by a small housing development called Honeymead. The old picture was taken from the railway; the new one looking the other way.

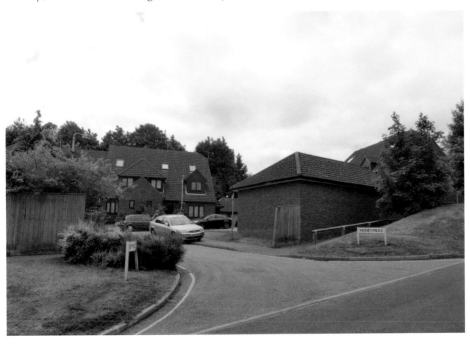